MW00575237

THE ART OF
RUTH E CARTER

THE ART OF RUTH E CARTER

Costuming Black History and the Afrofuture, from
DO THE RIGHT THING
to BLACK PANTHER

FOREWORD BY DANAI GURIRA

CHRONICLE BOOKS
SAN FRANCISCO

Night - Three

Library of Congress Cataloging-in-Publication Data:
Title: The art of Ruth E. Carter : costuming Black history and the
Afrofuture, from Do the Right Thing to Black Panther / Ruth E. Carter,
foreword by Danai Gurira.
Description: San Francisco : Chronicle Books, [2023]
Identifiers: LCCN 2021053651 (print) | LCCN 2021053652 (ebook) |
ISBN 9781797203065 (hardcover) | ISBN 9781797203591 (ebook)
Subjects: LCSH: Carter, Ruthe. | African American women costume
designers—Biography | Clothing and dress in motion pictures. |
Costume—United States. | Costume design—African influences. |
Costume design—African American influences | Fashion in motion
pictures. | African Americans in motion pictures. | Afrofuturism.
Classification: LCC TT505.C3757 A3 2022 (print) | LCC TT505.C3757
(ebook) | DDC 746.9092 [B]—dc23/eng/20220309
LC record available at https://lccn.loc.gov/2021053651
LC ebook record available at https://lccn.loc.gov/2021053652

Manufactured in China.

Design by Allison Weiner.

Cover image: Costumes from *Do the Right Thing* and *Malcolm X*,
photographed by Awol Erizku for *The New Yorker*.

10 9 8 7 6 5 4 3

Chronicle books and gifts are available at special quantity discounts
to corporations, professional associations, literacy programs, and
other organizations. For details and discount information, please con-
tact our premiums department at corporatesales@chroniclebooks.
com or at 1-800-759-0190.

Chronicle Books LLC
680 Second Street
San Francisco, California 94107
www.chroniclebooks.com

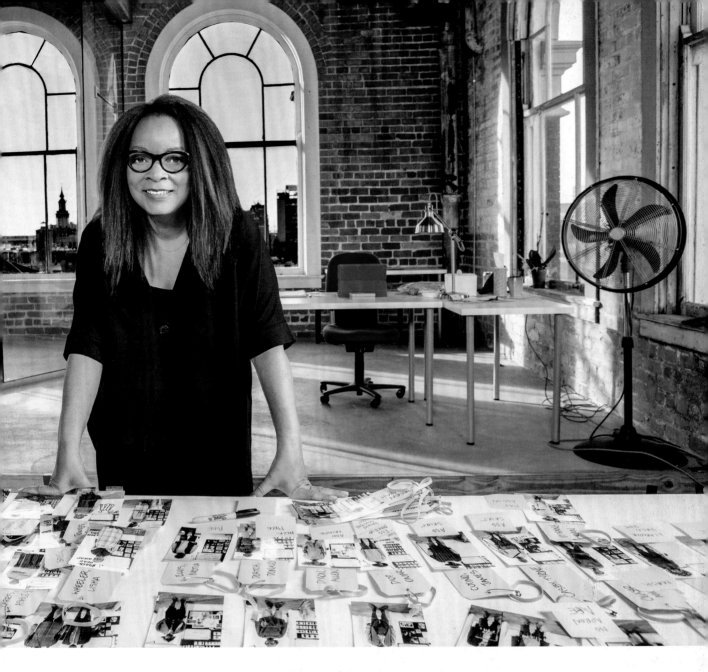

CONTENTS

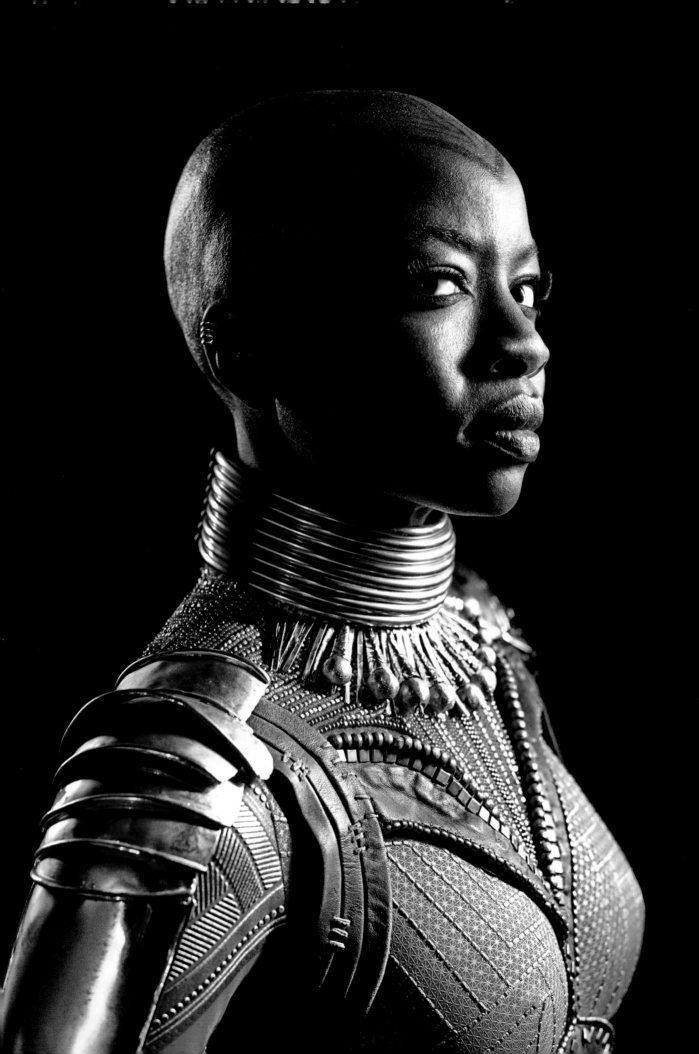

Foreword

I knew her before I met her. So many of us did. Her work was splendidly displayed across so many iconic cinematic moments. Bringing those moments to life. Making them more vivid, more memorable. Indelible. My first experience with Ruth Carter was as a young girl in Harare, Zimbabwe, drinking in the vibrant world of *Do the Right Thing* and reflecting on the profound mark the movie left on my young mind, of the life and culture of Bed-Stuy, Brooklyn. Then came the transformative power of the world she brought to life in the iconic *Malcolm X*—surging an entire new way to dress and express your Black pride, across the diaspora—and the unquestionable specificity of the period in the agonizingly rich *Amistad*, to so many, many more movies. Ruth Carter is a storyteller. She uses her craft to elevate a narrative, giving it an entirely richer and more potent delivery.

Having spent much of my life absorbing her work, knowingly and unknowingly, finally meeting her felt like a deep honor. *Black Panther* was a tall order, one that was utterly unprecedented. To bring this world to life was going to require a creative mind keen to fully explore, investigate, and research the many specific African cultures, aesthetics, and nuances that make the continent the most varied on the planet.

Then she was to fuse those together into one country's cohesive expression and make it futuristic to boot. Not for the faint of heart. But if you have spent any time around Ms. Carter, you will know, the word "faint" simply does not apply. Often portrayals of the African continent are general and nonspecific in Hollywood, never rooted in the astounding research material more than a billion people in over fifty countries could naturally provide. It has been a source of great frustration for me. Ruth served as a salve to that wound. Her articulacy around the world she invented was so vivid and true to the real people, real places, real experiences of Africa that I was literally nourished by her work as an actor on the project.

Entering her warehouse, I was engulfed in the most magnificent celebration of my people I had ever witnessed; across every wall there were images and research materials I never even knew existed. I was filled with pride and a whole new kind of knowing. From that experience I was able to translate a deeper understanding of my character's love, devotion, and undying willingness to sacrifice for the preservation of her people and their ways of life. I was invigorated and motivated by Ruth's approach to her task, bringing the splendor of the people of Wakanda to the world through the way they adorned themselves, be it in military uniforms or date-night outfits.

Ruth marshaled that deeply rooted work and crafted a world that took the whole world by storm. Amongst Black people, it ignited celebrations of their roots and heritage, and it gave cosplayers a heyday. Her approach to what she does, and the worlds she brings to life, is unquestionable in its meticulous craftsmanship. It's clear she immerses herself so deeply in the research, in the essence of the narrative, that she is able to create an aesthetic expression that will both ground and transport an audience.

The more I get to know her, the more in awe I find myself. To think she did iconic films as varied as *What's Love Got to Do with It*, *Selma*, *The Butler*, and *Love and Basketball* is to realize that she has been an intricate part of excellence in Black representation on screen for a generation. How utterly fitting that she is the first Black costume designer to be awarded an Oscar. She is also clearly a kind, loving leader, with a team that deeply respects her and with a mission to raise others from the community up as she climbs. As a playwright, I find the fact that she got her start in the theater no surprise; her level of depth and her willingness to collaborate while still retaining a palpable vision feels like the soul of a thespian.

It excites me to know this great tome honoring her work will now exist, encapsulating a fraction of her innumerable accomplishments but allowing us to live in her world and appreciate her brilliance and the incredible journey her work has taken us on. We are treated to the story of her life's journey and get the invaluable opportunity to peek inside a masterful artist's mind and process. It is no wonder that many who work with her seek to do so over and over again. Once you have experienced a Ruth Carter type of exceptionalism, how can you ever turn back?

Danai Gurira, 2022

Danai Gurira as Okoye in *Black Panther*

I have always been intrigued by the stories told by Black poets, playwrights, and African griots. Reading Langston Hughes, Sonia Sanchez, Maya Angelou, and others like them gave me life. I could feel their words in my core and see the people they painted so vividly with their writing. Through costume design, I was able to connect even more deeply to those stories when dressing the characters who come out of a script.

I grew up in Springfield, Massachusetts, the youngest of eight siblings. One afternoon, I unveiled a sewing machine tucked inside the desk in my room. I began making clothes from Singer sewing patterns, translating the cryptic words and directions. After graduating from high school, I followed my family legacy, studying special education at Hampton University, the historically Black college on the shores of Virginia.

But I was still driven by the rich stories of African Americans and decided to follow that passion with a major in theater arts. I enjoyed being in the theater department, but as an actress. I wasn't involved in costumes at all in the beginning. I played the role of Beneatha in *A Raisin in the Sun* and Alberta in *The Sty of the Blind Pig*, discovering even more playwrights like Douglas Turner Ward. My talents as an artist only fully emerged after a professor asked me if I thought I would like to do costumes for one of his plays.

Clockwise from top left: Ruth in 1973 giving her report at Amherst College High School Summer Program; Ruth in 1975 having fun with friends at Upward Bound, another summer remedial education program at University of Massachusetts; Ruth onstage in Clare Boothe Luce's *The Women* at Hampton University in 1982.

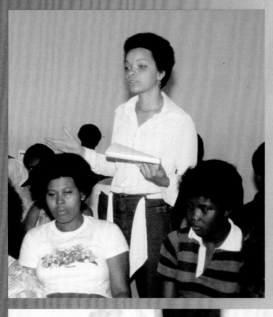
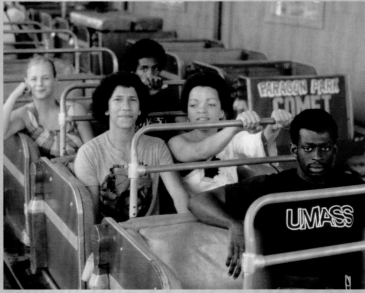
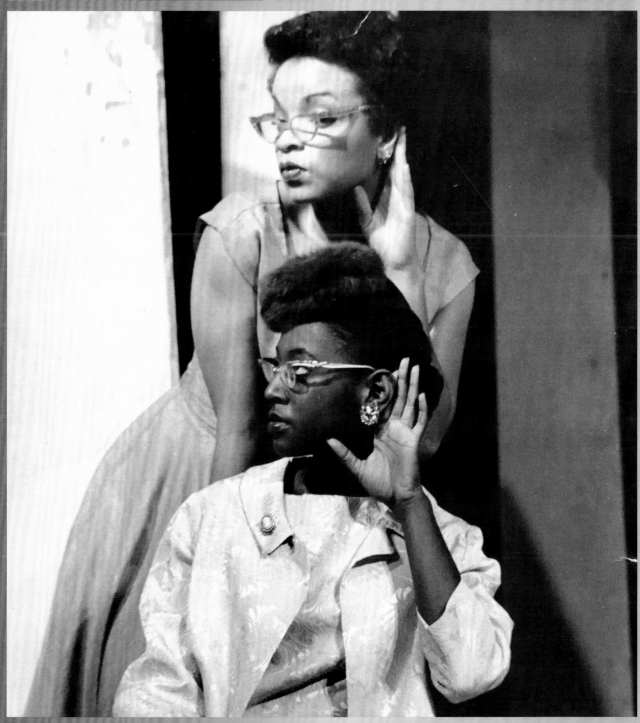

Then, in 1986, at twenty-six years old, I found myself cruising in my '84 Volkswagen Rabbit to Los Angeles along Interstate 5.

It was a little disappointing to be offered the costumes because I really wanted to act. Little did I know that this was the beginning of it all.

I was given the key to a small abandoned costume shop and found my workshop, my haven. This creative space was all mine. I soon found myself *the* costume designer on Hampton's campus, designing not only the school plays but also the music department musicals, step shows, and the traveling school dance company performances.

Following my graduation, I returned to Springfield and did an internship at a local theater, then packed up my car and drove to New Mexico to intern at the Santa Fe Opera. I felt these internships were necessary since I was self-taught in college. Working in a professional costume shop gave me an even stronger foundation. I sewed all day, and in the evenings I dressed the performers. I really enjoyed the work. Hearing the audience enter the theater in anticipation of the night's performance was magical. The fast changes of costume we teamed up for in the wings gave me a feeling of being a part of the performance. They were fun, and I was proud to hear the applause as a result of our quick work.

Then, in 1986, at twenty-six years old, I found myself cruising in my '84 Volkswagen Rabbit to Los Angeles along Interstate 5. And as I got closer to the city, the California Highway Patrol performed their "round robin" maneuver, crisscrossing their vehicles right in front of my car. It felt like I had a police escort—a welcoming committee. Even though they were just slowing the traffic down, it seemed a grand introduction to a new adventure that was before me. I felt excited, amazed by the grand city skyline, and invited.

Later that same year, I was hired as a dresser for the inaugural season of the Los Angeles Theatre Center (LATC). My first professional job. By the end of the season, I had talked my way up from a backstage dresser to a much higher position as the costume-shop foreman. My prestigious internship at the Santa Fe Opera had impressed everyone and landed me the promotion. But unfortunately, it was not the position for me. I didn't want to be an administrator—I wanted to be a costume designer.

The costume stock I had access to became a resource for creating work. I switched out of the foreman position at LATC and began assisting designers who were hired to design the plays. I sometimes assisted on more than one show at a time. One day a dance company came through with a show called *A Night for Dancing*. They were a local troupe out of South Central Los Angeles. They performed several dance numbers to the music of Stevie Wonder's *Songs in the Key of Life*. The show was amazing. But I noticed that they could use a costume designer. I talked to the director/choreographer about what I wanted to do for the show, and before I knew it, I was traveling with the company. I could watch the show night after night and never get tired of it. It was during this time that I would have a chance meeting with Spike Lee when he attended the show.

Spike, back then, was an up-and-coming filmmaker. He wasn't the well-known director he is now. Yet he already had a gravitas, a confidence about himself that emanated through his eyes and his manner. He was a true New Yorker. I could feel all that Brooklyn in him from the very beginning. He was invited to the show by my college friend Robi Reed, who introduced us. After the show, a few of us hung out at a dance club. We sat at a small table and began to talk about filmmaking. I wanted to talk about theater. Then Spike started to tell me how to gain experience in film, something I hadn't even considered doing.

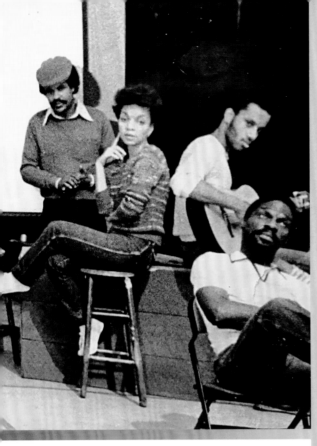

Ruthe Carter
Springfield, Mass.
Speech and Drama

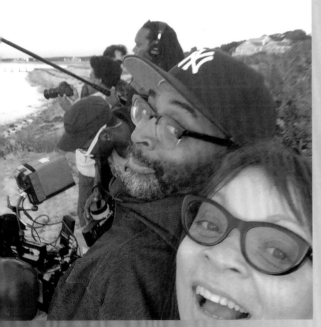

Clockwise from top left: Ruth in rehearsals at the Mono Community Center in Newport News, Virginia; Ruth's sophomore yearbook photo (her uncle was so embarrassed he told her mother to take her out of school); Ruth in Atlanta prepping for her first film, *School Daze*; Ruth with Spike Lee and crew in Martha's Vineyard, on the set of *The Sweet Blood of Jesus*.

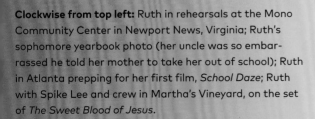

This book is about my creative process, from idea to manifestation, behind the making of the award-winning costumes as well as the career-defining moments.

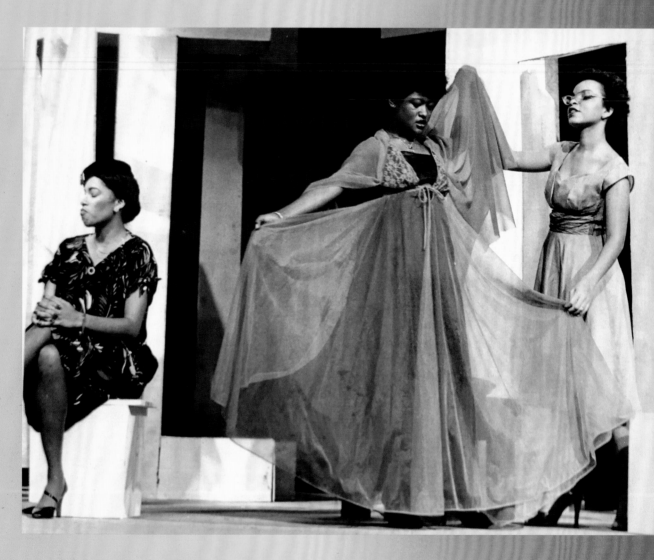

Weeks later he invited me to a prescreening of his new film, *She's Gotta Have It*. I was working hard every day in the theater, and I wasn't thinking at all about the film business. But when I took the time to attend a screening, I watched the lead character, Nola Darling, walking through the streets of Brooklyn, and I thought, "Let me at it! I know I can do this!"

During our brief encounter, Spike advised me to sign up at the UCLA or USC film studies department to work on a student thesis film. I decided to do it. Before long, I found myself on weekends listening to "Cut" and "Quiet on the set!" for the first time. What I couldn't believe was how simple it all seemed. I'd come from big period operas with fast changes in the wings. This seemed far too simple. I was on the set of the student film watching two people have a conversation while sitting side by side on a porch swing. I could barely hear their voices. The story seemed much more reality-based than the big theater-production medium I had come from. I thought to myself, How do I understand my contribution to this? What does it require, since to me they're wearing not a "costume" but normal clothing? How can I be a costume designer and tell this story? Later, I understood that this clothing is still a costume. I started to understand the relationship of texture, color, and pattern that connected to the relationships between the character and their environment within a medium that magnifies the details. This also creates the same impression in our minds in storytelling.

I freelanced for other costume designers, aging and dyeing their costumes in the bathtub of my studio apartment. Occasionally, I'd deliver my work to them and get to drive onto a studio lot or stop by a production office. I thought the film world felt very transient, unlike the established costume shops I had grown to know so well. I met costume designers working in office buildings with no permanency. There were no industrial-size sewing machines—mostly racks of clothes and shopping bags everywhere. I couldn't make sense of how this was the costume-design world. But at the same time, I was intrigued by the challenge of getting to know it better.

When Spike invited me to work on my first film, it was the beginning of a twenty-five-year journey taken together by a costume designer and a director. Each day, I was challenged to grasp the film medium and to be inspired, to have a purpose with my work. These challenges were a joy. "Purposeful work" is the thing that fueled the rest of my career. I knew from my beginnings at 40 Acres and a Mule that I could not only design costumes but also express the heart and soul of Black people, their culture, their nuances, my personal experiences as a Black woman, and the character details I found the most interesting. It was no longer a theatrical event. It was now the beginning of a journey.

This book is about my creative process, from idea to manifestation, behind the making of the award-winning costumes as well as the career-defining moments. It's also about the impact that African-inspired costumes have had personally and globally since that history-making moment when I became the first African American to win the Academy Award in Costume Design.

Ruth in 1982 at Hampton University, playing a saleswoman in Clare Boothe Luce's *The Women*.

I n 1987, I began the journey of creating my first feature film, *School Daze*. I was living in Koreatown, in Los Angeles, in a studio apartment with a nice view of the Hollywood sign. I slept on a mattress on the floor. I had a small beige loveseat with one cushion that I bought at a going-out-of-business sale. Early one morning the phone rang. I answered, "Hello?" A voice on the other end said, "Ruth." I said, "Yes?" The voice said, "Ruth." I said, "Yes." The voice said, "This is the man of your dreams." I then said, "Denzel?" The voice exclaimed, "No! This is Spike! I want you to be the costume designer for my next film, *School Daze*!" I immediately quit my theater job. No contract, no negotiations, just trust and passion.

Spike delivered the script, and I began breaking it down, imagining the world as it was written. I had never done a film before, but somehow that never crossed my mind. I'd been working in theater for a while, and I felt I knew the mechanics of building a character with costumes. So, there was a sense of comfort in my background. What I didn't know, I quickly learned, I could get from Spike.

I decided that I would need some coaching from my brother Robert, the artist, on creating sketches and organizing ideas for this big opportunity I was given. So, I locked up my apartment in LA and flew across the country to New Hampshire, where Robert lived and had a full-on artiste studio.

Costume sketch for
Jane Toussaint

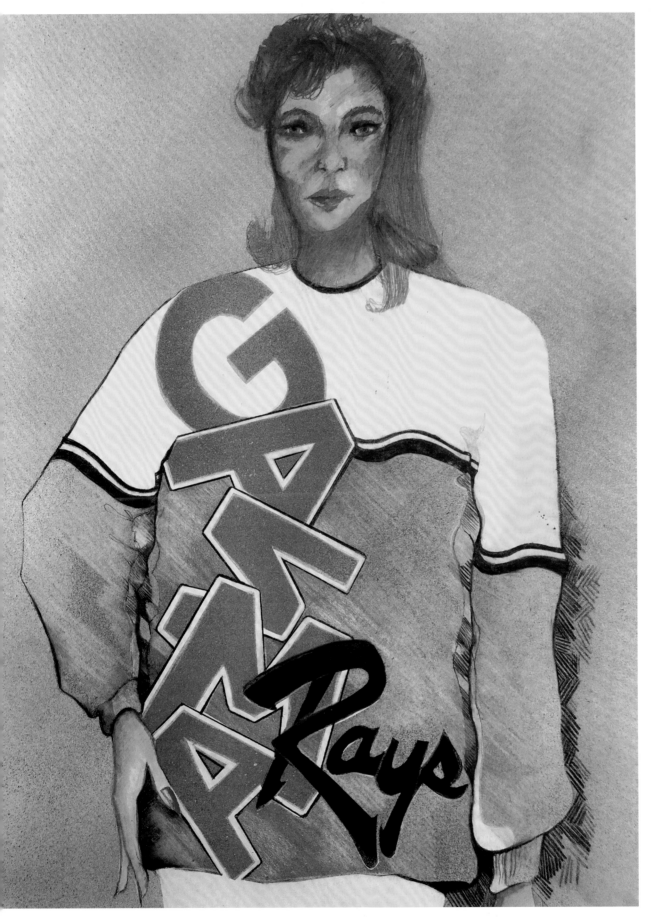

I made a list of all the characters in the film, and with my brother's advice began working on the script, the budget, and, most of all, the costume illustrations. I drew every character in the script, including the characters who had no lines. I was driven by the opportunity. The advice Robert gave me was solid. A visual artist himself, he advised me on how to organize my artistic ideas. He let me use his computer to type up a detailed budget. We laughed a lot, and I made him screwdrivers until he fell asleep in his big armchair. It was a pivotal time in my life, when I was beginning to find my voice as an artist. I treated it like a job, even though there was no pay. I didn't think about that at all.

When I was done with my drawings, I packed up everything in an enormous portfolio case that my brother loaned me and took it with me on a bus from Boston to New York. When I arrived at Penn Station, I called Spike and he gave me complicated directions on how to take the subway to his apartment in Brooklyn. I stumbled down the steps and through the turnstiles with this monster case. I was exhausted by the time I arrived at his basement apartment door in Fort Greene. I walked into his living room and laid everything out on the floor. My brother had instructed me to ask him to sign the illustrations that were approved. I could tell he was impressed and happy with all the work that was done, even though he never said it to my face. Then I returned to Los Angeles and waited to "get on the books."

Months later, I returned to New York City and, finally, to the headquarters of 40 Acres and a Mule Filmworks, Inc. (Ya-Dig, Sho-Nuff, By Any Means Necessary), Brooklyn. At the time, it was in a newly renovated firehouse on DeKalb Avenue.

When I was done with my drawings, I packed up everything in an enormous portfolio case that my brother loaned me and took it with me on a bus from Boston to New York.

Above: Costume sketch for Dap Dunlap
Opposite: Costume sketch for Julian "Big Brother Almighty" Eaves

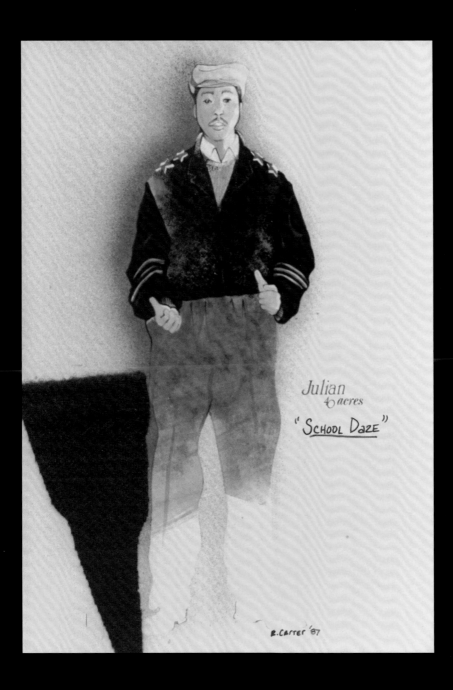

Julian
40 acres

"School Daze"

R. Carter '87

IT WAS ME, NEW YORK CITY, AND SPIKE LEE.

Spike's office was on the second floor. Inside his office was a small loft that I made into my space.

The office of Spike Lee, where film preparations officially commenced. There were a few things I didn't know, or that didn't necessarily cross over from theater to film. Even though I'd done so much design preparation, I wasn't ready for the experience of being pulled in many directions. It provided me with many valuable lessons about the filmmaking process. There at 40 Acres, I would find my first film family. In the small loft, I continued breaking down the script and imagining the concepts. My first costume was a T-shirt with a drawing of Nelson Mandela to be worn by Dap, played by Laurence Fishburne. My second costume was the "Dog or Die" crest to be used on the Gamma Phi Gamma letterman jacket. I had graduated from one of the historically Black colleges and universities (HBCUs), Hampton University, so Black sororities and fraternities were familiar to me. I designed many other T-shirts that read "Uplift the Race," "BLACK by Popular Demand," and "Mission College," and hockey jerseys with a small "J" for "Jigaboo" and a capital "W" for "Wannabee."

It was a lot of fun, and Spike was "into it," occasionally giving me handwritten notes with his own design ideas, including his request for the Gammites to have a unique look as the pledges of Gamma Phi Gamma. Spike is very much a sports fan, loves the New York Knicks, and he requested that we take the subway together to a sporting goods store in Manhattan to buy all of the equipment to be worn by these pledges. We walked from 40 Acres to the subway station and rode into Manhattan. This mode of transportation was all very Spike Lee, having grown up in New York. Some people in his neighborhood recognized him as the prodigal son of bassist Bill Lee, and the young, aspiring NYU film school graduate. (Back then, he rode the train everywhere.) It was me, New York City, and Spike Lee. We arrived at the store and walked around, picking up several items like elbow pads, goggles, T-shirts, and shin guards—one set for each of the nine pledges. We quickly became a spectacle in the store as the amount of merchandise began to build. A massive mountain of items began to grow at what became our very own checkout counter. As we wound down, Spike looked at me and said, in his own Spike Lee manner, "Allll riiight. Knicks are playing at the Garden. See you later."

I guess a part of me thought we were together on this journey full circle. So, when he told me he was going to the game, I thought, Oh no. Now, what do I do? I looked up high on the wall and they were selling enormous duffel bags that were for hockey equipment. I said, "I'll take one of those." The store employees helped me pack the merchandise in the duffel and came outside to help me hail a cab. It was that time of day when cab drivers go through a shift change, and it was very hard to get anyone to stop, but we finally got one reluctant cabbie who, before he would unlock the door, rolled down his window and asked where I was going. I said "Brooklyn." He happened to be heading home that way and unlocked the back door. The duffel bag was so big it took up the entire back seat, to the point where I had to sit in the front. I made it back to 40 Acres. As I got out of the cab and pulled the enormous bag out of the back seat, someone walking by said, "Hey. It's Valentine's Day. You shouldn't be doing that." Although the struggle was real, I was returning with costume components to do the thing I loved to do the most. It was bigger than Valentine's Day. I realized later that there would be many more Valentine's Days in my future and a few more that it would be okay to miss.

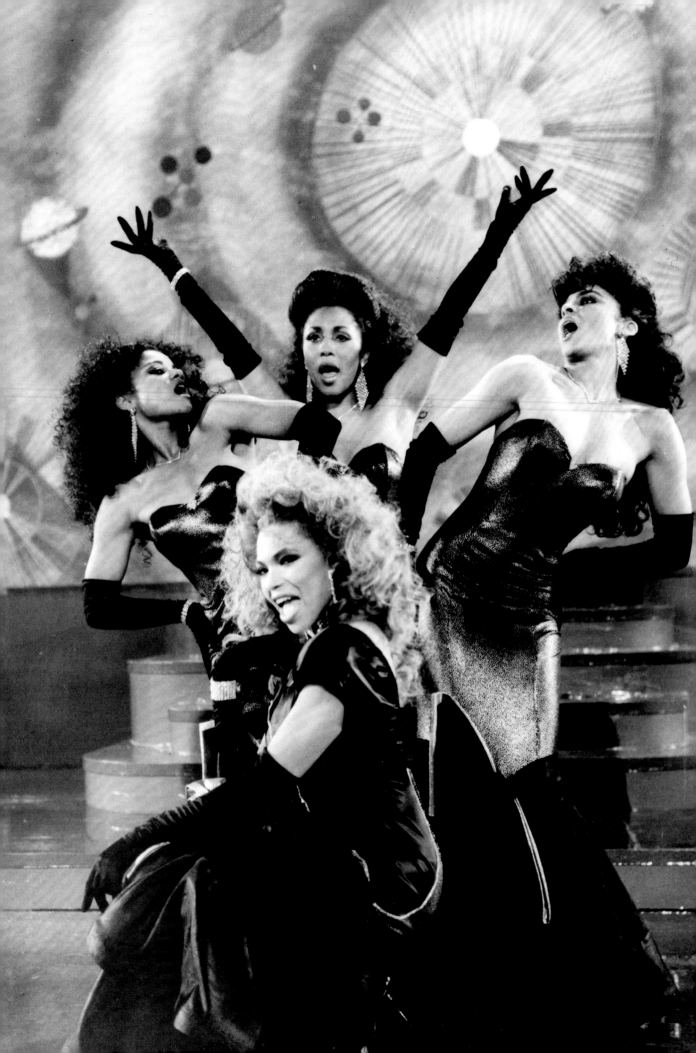

Things got better. I took on all aspects of the design of the film, including the Gamma Rays' performance at Mission College's homecoming to the original song "Be Alone Tonight." I didn't set up a workroom at 40 Acres; rather, being very familiar with theater and how the theater community is very supportive of each other, I had costumes made at the theater costume shops around the city.

Per Spike, I needed to go into the city and select costumes that were to come from Willi Smith of WilliWear. I was unfamiliar with this new black fashion designer and soon found myself inside the elevator in a high rise going to speak to one of the first African American fashion designers on Seventh Avenue. When I arrived, he was soft-spoken and seemed to be curious about the movie process. What was I looking for? What was the film about? And as I looked around, I could see his aesthetic—very eighties with a boxy silhouette and shoulder pads. He told me he would be happy to custom design and make something special for the film, and that's when I thought he would be perfect for the homecoming queen and her court. Willi designed and executed the manufacture of the pieces without a hitch.

The transition I made from prepping the film in Brooklyn, New York, at 40 Acres to shooting in Atlanta, Georgia, in an abandoned warehouse, was tremendous. I can't say that I handled it very well or was prepared for working with so many actors at one time. We lived campus-style in hotels. I was often greeted in the lobby and in the hallways with requests from actors my same age, and it never stopped. It was my first film, so I had no real reference to compare this experience to other than my own personal "school days" experience, and yet, this wasn't school at all.

Opposite: Jane Toussaint (Tisha Campbell) and the other Wannabees perform at Homecoming
Right: Costume sketches for the Homecoming scene

Velvet bodice
Maroon gloves

Organza skirt

—Maroon Velvet Bodice
Maroon Satin tra

Organza Skirt

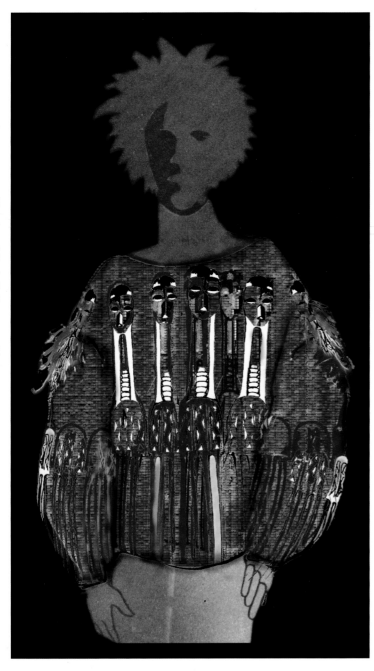

Costume sketch for Rachel's sweater

Spike was demanding. I was the head of costumes, and it seemed as though everyone wanted something from me. Overwhelmed at times, I set up fittings with dozens of actors in scenes of frats and sororities, step shows, pledges, dorm confrontations, musical numbers, parades, and football games. I worked from sunup to sundown organizing outfits with my team of costumers. One day, while filming the homecoming parade scene, Laurence Fishburne came up to me and showed me that a red, black, and green freedom pin had fallen off his jacket. I took another pin of the same size out of my bag and began painting the same symbols on it, replicating the lost button. He stood there smiling as I matched the graphic. It was exhilarating! Even though it was just a pin, I felt I had the skills to work fast and, in the moment, keep the integrity of the scene. Unfortunately, there were other emergencies like that one still to come.

There was the handmade sweater that I designed and had knitted for the film. It was a beautiful orange color with tribal masks and fringe knit into the design. I asked my theater mentor, Georgia Carney Darling, to knit the sweater. Georgia was a costume cutter/fitter from the local theater company in Springfield, where I had been an intern. I remembered Georgia's incredible knitting skills. She loved knitting and made beautiful pieces for herself and her husband. I thought I would ask her to knit a sweater for my first film. Georgia obliged. She explained to me how to grid out my pattern design and which yarns to pick out for the best result. Soon the sweater was done, and it was a crown jewel. The principal actress wore the sweater in the film, and everyone could see how special it was.

I felt like I was playing a significant role in amplifying the voices of Black filmmakers.

Then, towards the end of shooting, maybe the day before our last day, I packed the sweater in a box, preparing to ship it to myself in Los Angeles. I knew people had their eyes on it. I wasn't going to let it get away. At the time we were selling everything from the show. Everyone, cast and crew, was buying their cool wardrobe as keepsakes. I had my list too, and that African sweater was on it. At that moment, a big controversy arose between the script supervisor and Spike. The script was unclear about the passage of time before a scene that involved the sweater—and whether we were going to need it again. It was determined that the sweater was still in play.

My packed boxes were no longer in the lobby of my hotel; they had been picked up and were on their way to where air cargo was held in Atlanta. I called the air-transport company and stressed over whether the sweater was in the air. It wasn't like we had bought it at a store and could just go buy another one. I'd had it made from scratch, and only *one* was made. I felt like all the arrows were pointing at me. An airfreight company representative came to the phone and told us that he'd obtained authorization for my boxes to be taken off the plane, but we would need to have the person who signed the check with us when we came to pick them up. I realized that Robi Reed, the casting director, and I were shipping our things together and she had signed the check. It was late at night when I found Robi. My assistant recruited a local Atlanta production assistant to drive us, and we headed to the airport airfreight company. What did we expect? We were in the South. The airfreight company was in the boonies. We were on a tight deadline, and getting lost was not an option. But we got lost anyway.

We stopped to ask for directions at local stores on the way. Then it started to rain. And we still couldn't find the place. Our deadline was 9 p.m. and it was coming up fast. So, we stopped at a pay phone. I called the company. With the big trucks going by, it was hard to hear the guy on the other end. I could barely make out that he was telling me that he would meet us at the convenience store where we were making the call, and we could follow him the rest of the way. When does something like that ever happen? We arrived and the boxes were sitting out on the small, private airstrip. I knew exactly which box to open, and it was there. Sigh of relief. We were happy that our mission was accomplished. We were so grateful to the man who helped us that we gave him a *School Daze* T-shirt right out of the box.

My *School Daze* experience completed my breakthrough into the film business. I traveled back to Los Angeles to my studio apartment, bought a new bed, and gave my love seat with its one cushion to a friend. I was immersed in a time of transition in pop culture. Rap and hip-hop were brand-new, filmmakers were creating independent films, and I felt like I was playing a significant role in amplifying the voices of Black filmmakers. I was excited and ready for my next challenge. I began working from coast to coast. After *School Daze*, I went back and forth between 40 Acres, every year, and Los Angeles, costuming films like *The Five Heartbeats* and *Mo' Better Blues* and working back-to-back for many other directors, actors, and producers in the early nineties—to whom I will be forever grateful for giving me the opportunity to collaborate with them, to express my art through costumes, and to learn about filmmaking.

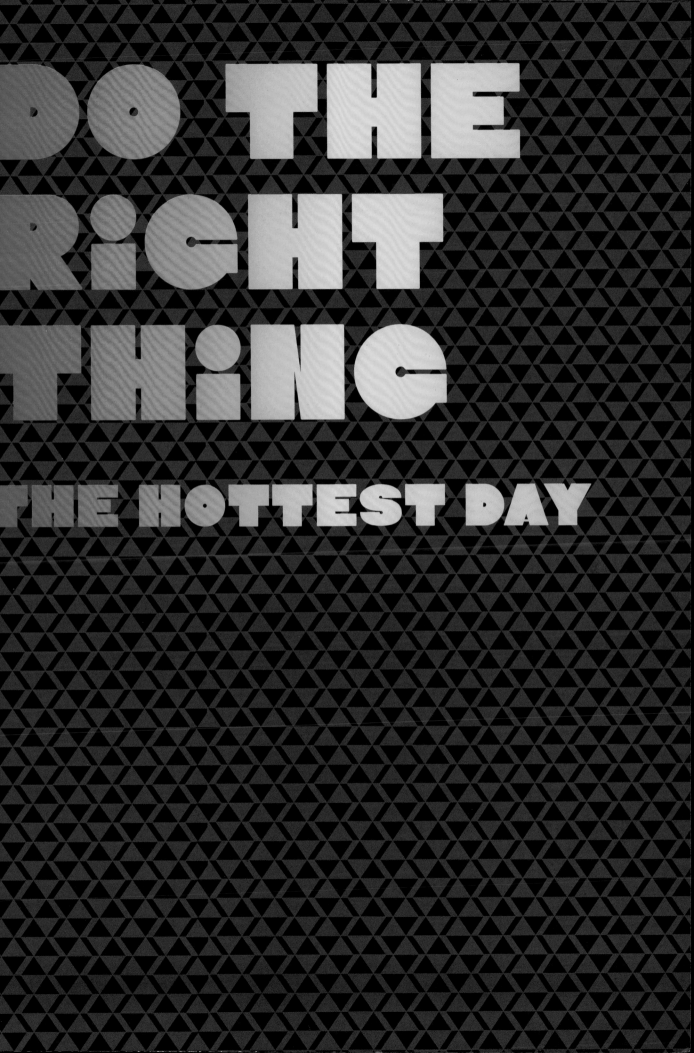

A year after successfully meeting the many challenges on Spike Lee's first studio film, *School Daze*, I returned, by Spike's invitation, to Brooklyn's own 40 Acres and a Mule to talk about beginning his latest work, *Do the Right Thing*. It was exciting to pair up with Spike again. I had hoped that he thought I did a good job and wanted me back. Spike is very hands-on when it comes to the who, what, where, and how of his projects. If you are participating, it is because *he* said so. I marveled at the fact that he wrote the first draft of the script in just two weeks! He also boasted about it. I guess that's how I knew. But I took that in and thought of him as this maverick. And I especially wanted to know about the costumes he would ask me to create for the film, set in his childhood home—a place I had grown to love as well.

Spike and I used to walk from his 40 Acres office, housed in the restored firehouse on DeKalb Avenue, to a local café or restaurant to talk about our issues from the last film, easing unresolved tensions, like who was stealing the Nikes from our warehouse. Usually, the issues had to do with not having enough multiples of a certain costume to shoot a scene. None of it seemed to matter as much anymore. Now we had a brand-new script and a new story to craft. It was nice to sit and have lunch with Spike. Our meeting went well, because we were far removed from the intensity of being on the set.

Costume sketch
for Sal

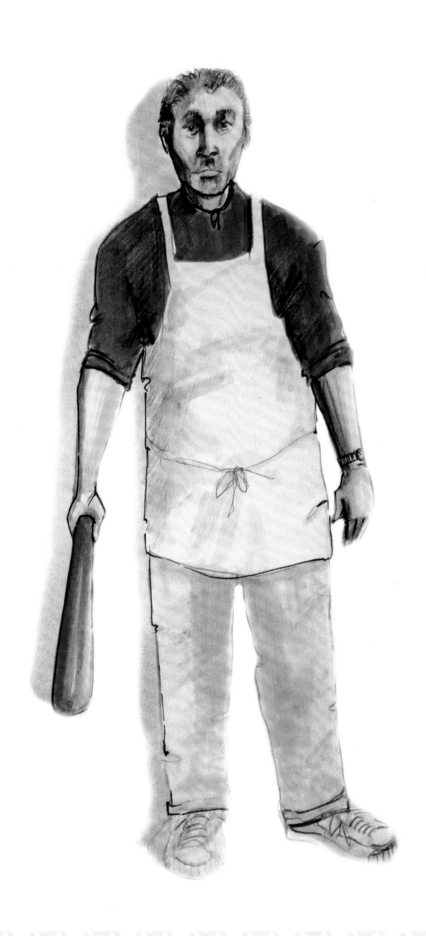

Instructions from Spike:
"THIS FILM IS GOING TO HAVE TO LOOK HOT!"

I really don't remember at all what I had on my plate that day; I remember more that Spike was generous and human. That first film experience had left me with feelings of not measuring up to Spike's standards. He was the only filmmaker I knew at the time. Now, returning felt like being a part of the winning team. We quickly left the past behind and moved onward, discussing the details.

Spike sat across the table, looking down into his handwritten address book, and spewed off the personal telephone numbers of the cast he'd chosen for the film: John Turturro, Rosie Perez, Bill Nunn, and others, some of whom seemed to be personal friends of Spike's. "Here. Take this number down. That's John Turturro. Call him today. He has some ideas for his costume."

My first script note was: "It's the hottest day of the summer." Instructions from Spike: "This film is going to have to look hot! Everybody is sweaty. And you know, in Nueva York when the weather is hot, when the temperature is up, up, up, the tempers run high, high, high." Then he let out a whale of a laugh. We were making a protest film. It was addressing some of the racial tensions that had recently played out in Brooklyn and the surrounding neighborhoods. The political climate of New York in the late '80s and early '90s, with multiple racial incidents against Black people, having the first Black mayor, the Howard Beach incident, and the first Black mayor, the Howard Beach incident,

and the Tawana Brawley hearing, all gave people a reason to be roused up. This was the impetus of the story. And Spike was clear: Tawana told the truth, Iron Mike Tyson was Brooklyn's finest, and Public Enemy would write the protest song for the film.

How would we make it a neighborhood? How would we keep the story real as it eventually erupts into a riot? "Also, the cast will need to look sweaty and wear lots of summer shorts and summer tops!" Spike spewed. He wanted me to make special crop tops and midriffs for the ladies and basketball shorts for the men. We walked around the set all day with spray bottles filled with glycerin and water, spraying people under the arms and on the chest. This was great in June and July. But when the fall started to creep in during late August, the cast really felt the chill.

Second note from Spike: "4-finger love-hate rings, a must." It was written in the script. I had no idea where to get them made. I had a local guy make a prototype, and it really looked bad. Then Spike said, "Go to one of the jewelry stores over in the Fulton Mall." A few weeks later, from right there down the street from the office, arrived two beautiful sets of love-hate brass knuckles for Radio Raheem.

The leather necklaces worn by Buggin Out were also requested by Spike. It was in style to wear something African in Brooklyn and Harlem. Culture was everywhere. But it was truly in direct opposition to the massive amounts of gold being worn by many other urban youths, especially Black inner-city kids. Spike would have none of that. Instead, he insisted on these handwoven necklaces, which were purchased off the tables of street vendors from Brooklyn

to Harlem. They were very popular. Giancarlo Esposito, the actor who played Buggin Out, added his own personal crystals to his collection of necklaces.

The trust and camaraderie at the beginning of a new adventure with Spike Lee was priceless. There were many logistical challenges in costuming the film, which takes place over the course of a single day. How do we shoot the same costumes that people would wear every day, for fifty-five days of shooting? There would be an opportunity for the characters to change clothes only after the fire hydrant was opened. This water scene required aqua socks for the shooting crew. Also, we needed to use Nike's product placement as a resource since we would have to make the film on a tight budget. The Nike apparel came in very handy. They gave us plenty—not only the sporty looks of compression shorts under regular basketball

shorts, but also aqua socks and sneaker after sneaker.

But the Nike apparel was very bright. Glance in any direction around the Bedford-Stuyvesant neighborhood of Brooklyn, the setting of our film, and there was a different message and color story. Then, you notice the layers of socioeconomics, strife, cultural expression, and muted tones. And it was very unusual for a Brooklyn neighborhood to wear that much Nike at one time, on one block. I knew that all this bright Nike product placement had to work within the storyline and color palette. It was challenging. So, I started to create outfits out of African cloth that were equally vibrant and saturated, to balance the colors of the Nike products and to inject the cultural realism that I knew of as Brooklyn into the costumes. African inspiration was a daily occurrence, with women and men wearing African patterns. Brooklyn was a place where cultural garb was a way of life.

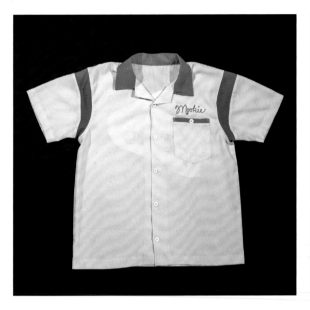
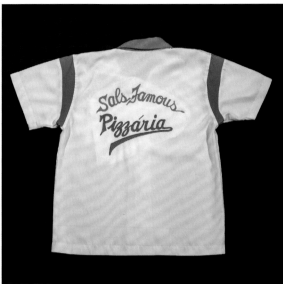

Mookie

Spike Lee

The Jackie Robinson jersey was Mookie's first costume (he wears two in one day), bought and paid for by Spike Lee himself. He handed it to me one day, saying, "I'm gonna wear this." There was only one of this jersey, so I didn't want to use it during the riot or water scenes.

Mookie's second look was a bowling shirt in the colors of the Italian flag: red, green, and white. This idea came directly from Spike. I chose the style and embroidered "Sals Famous Pizzária" on the back. He wore compression shorts that were yellow and green, underneath cotton basketball shorts. The colors of his socks—also yellow and green—coordinated with the whole outfit. And, of course, he was to wear Nike shoes handed to me by Spike himself: Air Trainer 3 Medicine Balls. Mookie's watch was a little red car that he wore on his wrist. I thought of him as the catalyst of the story—he's connected to everyone, feeding them conversation and pizza.

I THOUGHT OF HiM AS THE CATALYST OF THE STORY—
he's connected to everyone, feeding them conversation and pizza.

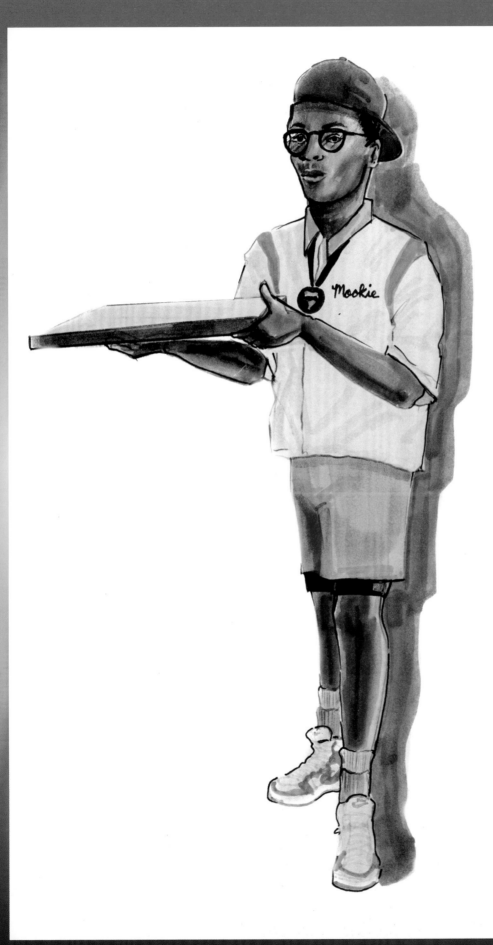

Sal, Pino, and Vito

Danny Aiello, John Turturro, Richard Edson

Sal and his sons arrive at Sals Famous Pizzária, the neighborhood pizza parlor, in a big white El Dorado. Pino, the eldest son, is dressed to the nines. John Turturro expressed to me that he wanted his costume to separate him from everyone else and to be black. Pino arrives in black silk and changes clothes into his uniform: white apron, white tank top. This story was about the tensions between races that ignites beyond the heat.

Vito, the younger son, has developed friendships in the Black neighborhood. He arrives at Sal's in his summer B-boy shorts and doesn't change his clothes that day.

But Sal changes out of a cactus-print Hawaiian shirt and into a long-sleeve green cotton L.L. Bean shirt. Now, they are ready for the big trouble to come.

The whole neighborhood enters Sal's for pizza at some point. The colors they wear are in direct opposition to the black-and-white photographs on the wall.

Da Mayor

Ossie Davis

Da Mayor wakes up and proclaims, "It's hot!" When early mornings are hot, it's a warning that something crazy is about to happen. The mayor hustles down to Sal's Famous to sweep the front walk for small change. I put Da Mayor in a seersucker suit that I aged down. My days in theater inspired me to create a costume for him that was artistic and imbued with a story. It would be poetic, telling his past and a bit about his lifestyle. Since he lived in an apartment and wasn't homeless, I wanted him to present himself as someone of importance, hence the suit. And even though his bout with aging and alcoholism was very apparent, he was known as "Da Mayor" to the whole neighborhood. He was proud as he stumbled after tipping his hat. It was imperative that Da Mayor also look like an unforgettable presence on the block. I exploded a pin in his pockets and filled them with rocks to show wear. I gave him very inexpensive shoes, and I faded his color palette to near transparent in opposition to the extremely vibrant and saturated palette worn by the youths on the block. Somehow, the heat and the vibrant colors all belonged to the younger generation in the film.

Costume sketch for Da Mayor

THE PROTEST BEGINS WITH BUGGIN OUT.

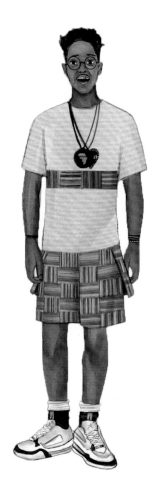

Buggin Out

Giancarlo Esposito

The protest begins with Buggin Out, the revolutionary, the harmless strange guy, the lone wolf. Buggin Out became the character who would connect the dots. We needed to show a radical boy, whose thick glasses and road-warrior attitude would make him unlike anyone and yet still a kid. The glasses are considered a prop. I know Giancarlo put in a heavy prescription to make him look bugged out!

I used bright Nigerian Kente cloth for his cargo shorts and yellow tunic as he walked through this film recruiting fellow protesters.

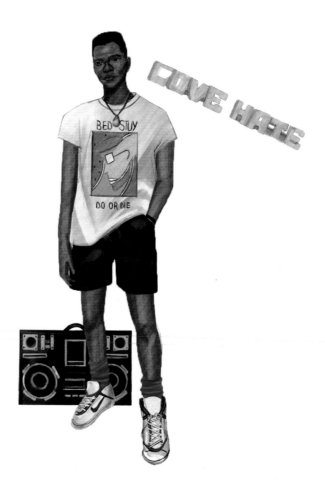

Radio Raheem

Bill Nunn

Radio Raheem becomes drenched in sweat as he recruits. His basic outfit doesn't change, unlike the other characters' outfits, and it shows the heat of the sun and his sweat. We didn't change his clothes, because he doesn't get wet when the fire hydrant is opened. (Everyone else in the neighborhood plays in the water, so they change their clothing.) His shoes were handpicked by our own sneaker head, Spike Lee, and were Nike Air Jordan 4 White Cements. On the front of the shoelace, I tied a wrist bracelet made using the colors of the Pan African flag.

I loved Brooklyn. It felt like a small city full of interesting people and neighborhoods. On Saturdays I would walk to the local Jamaican-food takeout joint or stroll Fulton and Flatbush, stopping in local shops. I noticed a cool bunch of T-shirts painted by local Brooklyn artist NaSha, and I really loved one of them, so much so that I asked her if she would paint the same shirt for Radio Raheem, with the saying "Bed-Stuy Do or Die." The slogan was written in Spike's script. To Spike, "Bed-Stuy Do or Die" meant "go hard or go home." He said, "It signifies the hustle and resilience of the neighborhood's people." The local fashion scene in Brooklyn was fascinating to me. They seemed to be on the cusp of what was hip and what was cultural. NaSha made me the shirt.

When we first got the shirt on camera, I suddenly realized we had spelled Bed-Stuy wrong. I immediately went to 40 Acres editor Barry Brown. He showed me Radio Raheem's first-day footage. I was saved—we hadn't shot much beyond him walking away. I went back to NaSha to have the shirts repainted with the correct spelling. She had lived in Brooklyn all her life and hadn't caught it either!

Mother Sister

Ruby Dee

I always loved it when Ruby Dee was on the set. It felt like flowers had just arrived, like there was our own Black Hollywood royalty. She was always smiling, and we took great pride in treating her kindly. And so, I dressed her like flowers on the windowsill.

The Corner Men

Frankie Faison, Paul Benjamin, and Robin Harris

The Corner Men sit on the corner in comfortable cotton. They were placed in front of a red wall, and I wanted to bring some realism to them. I wanted to separate them from that hot red and give them washed-out light tones. I saw so many of these men seated outside of the bodegas around Brooklyn playing dominoes. I didn't want them to be a surrealistic version of themselves. I wanted them to feel very real.

THEY WERE THE GREEK CHORUS IN THE STORY.

Kids on the Stoop: Ahmad, Cee, Ella, and Punchy

Steve White, Martin Lawrence,
Christa Rivers, and Leonard L. Thomas

The actors were all very excited and ready to express their characters with the latest urban fashion trends. Spike wanted Ella to wear a sailor hat; it was in style at the time. And the boys had variations of basketball jerseys and oversize shorts. But everything had to be mixed with a ton of bright, free Nike apparel and shoes. As far as costumes went, their support was huge.

The Korean Grocers

Ginny Yang and Steve Park

I dressed them as the owners of a family business but also as a part of the community, a young Korean family that felt akin to this community and yet were seen as outsiders by the community. Instead of using the youthful, saturated palette seen around the younger community, I kept them in neutrals. The father wears a guayabera, a shirt that is mostly worn by the Latino community and, for me, was the quintessential Caribbean man's dress shirt/jacket. It told the story of migrant citizens and the cultural nuances that they brought with them.

Clifton

John Savage

Clifton was played by John Savage—a great actor, one of the best in my opinion. He worked only one day. Spike, being a die-hard Knicks fan from a very young age, requested that John wear a Celtics T-shirt with Larry Bird's number. The Boston Celtics had beat the Knicks twice out of their championship run. So, the fact that Clifton was a white boy living in a Black neighborhood, and unapologetically wearing a Larry Bird jersey, created the perfect tension and story without needing any more than the one day.

Tina

Rosie Perez

Tina, Mookie's girlfriend, wears a yellow top with a big black bow. I remember tying the bow at the last minute to give her more cleavage. She didn't mind.

WE WANTED TO PRESENT A CHARACTER WHO WAS WORKING CLASS, A WOMAN WHO WAS CARRYING THE RESPONSIBILITIES OF HOME AND FAMILY.

Smiley

Roger Guenveur Smith

Smiley is the special-needs neighborhood guy. A character like him, to me, added that surrealist poetic element that you might find in a storybook. I gave him a basic uniform of a red shirt and gray Dickies. Smiley's costume was inspired by my real-life cousin Francis. He was a gardener whom everyone knew and was a little like Smiley. This uniform is what he wore to cut grass.

Jade

Joie Lee

I spoke at length with Joie Lee, Spike's sister, about her character and costume. We wanted to present a character who was working class, a woman who was carrying the responsibilities of home and family.

I also wanted to give all the characters of this community a unique style trend. I put a Swatch watch on Joie's ankle. At the time, I thought it could start a brand-new trend. Not so much.

MY
PERiOD
WORK

My period work includes *Malcolm X*, *The Five Heartbeats*, *What's Love Got to Do with It*, *Ty Cobb*, *Roots*, *Amistad*, *Dolemite Is My Name*, *Marshall*, *Selma*, *Lee Daniels' The Butler*, *Teen Beach Movie*, *Sparkle*, *Frankie & Alice*, *Black Dynamite*, *Summer of Sam*, and *Rosewood*. Each of these sixteen films had an impact on me as an artist and especially as a historian of period costume. Whether it was the intense research, the joy of re-creating the life of an iconic historical figure, discoveries along the way, or the great sense of purpose, working on these films made me feel stronger and deeply gratified. They also opened me up to beautiful examples of life as seen by the great photographers and painters of those times: James Van Der Zee, Charles "Teenie" Harris, Gordon Parks, George Caleb Bingham, Romare Bearden, and so many others. I carried many of them in book form along with me, in my backpack, in a drawer on the wardrobe truck, in my office, and everywhere in between. They served as advisers and references for the truth of my storytelling. I relied on their details and the way they completely captured a time period.

I was very comfortable doing period films. All my training was in that kind of work. I was very shy when it came to contemporary films. But period projects taught me how to research, and that worked for both types of films. To tell authentic stories full of color and texture, you have to do research.

Mood board for
Roots

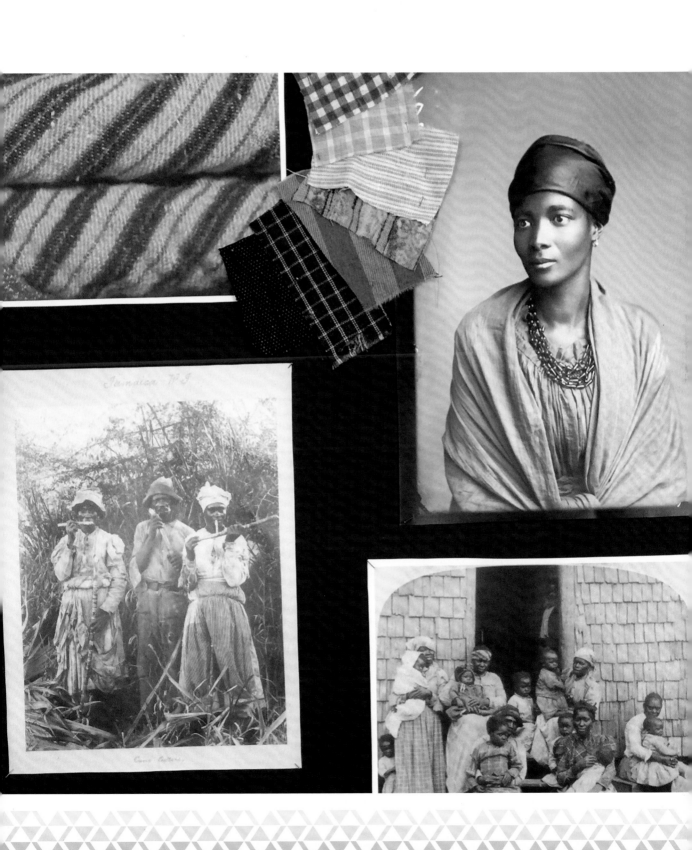

I felt my identity was wrapped inside my mom's story. She had the courage to take the next step and the courage to face all odds.

Many of my best character stories were extracted from my candid photos and from the vivid descriptions I found while reading poetry and prose. I could take in the words, like those from Langston Hughes in "Mother to Son," and I could imagine them. And the rhythmic voices of Nikki Giovanni saying, "Tired. Sick and tired of being tired." And Sonia Sanchez delivering prose about Black culture. Each text held its own personal liberation, and I was into it. I wanted to be a revolutionary. As a child, I remember hearing stories about my family when I would go down South to visit my grandparents. Stories of them working in the shipyards of Virginia near Chesapeake Bay. And stories of my mother leaving home to look for a better life for herself in the 1940s.

My mother's story fascinated me. She graduated from high school with honors. This was in the 1930s, "down South" in Bedford, Virginia. And back then, most Black high school graduates found themselves working as domestics. Mom decided to move north for better job opportunities, at the invitation of her Aunt Matte. She headed out alone, searching for something better, and landed in Springfield, Massachusetts, in the 1940s. She soon after got married and had eight kids. She divorced when I was an infant and raised all of us herself.

I felt my identity was wrapped inside my mom's story. She had the courage to take the next step and the courage to face all odds. All the stories I heard from her were about growing up in the South and were as colorful as they were intriguing. I identified with them. Being a "high yellow" girl with green eyes, I was very curious about my ancestry in Virginia. I experienced my mom's Virginia story on many summer trips as a child. I can still remember it vividly. My appreciation for Black history started as I learned about family history. I could see the faces. But I wanted more for my life, like my mom did.

I went to school in Virginia at Hampton University, an HBCU. At the time it was called Hampton Institute, and that is where I was introduced to the history of Blacks in Virginia. On the campus stood one of the oldest archives on African American and Native American educational history. I felt the Black American story was a family story, and that I was a product of it. Not only the stories of my family, but also those of my people who lived long before, came alive for me in Virginia. I desired to find out more about our collective history, so I traveled to the courthouses and libraries around the state to learn more about my Virginia roots and those of others. I paid particular attention to the imagery in Black history, impelled by a strong love for theater arts and, specifically, costume design. I embraced the incredible visuals and the emotional journey of Black history, brought to life by the historical accounts and photographs I studied.

The summer of my junior year of college, I joined the Colonial Williamsburg Foundation Living History Program. There, I worked as a street performer, walking around the grounds, telling the story of the Black people who lived there in Virginia. I performed two separate characters that I alternated each day. I did some serious research on these characters. A Black historian and professor, Reginald Butler, guided my research and helped me form my monologue for accuracy. I grew to appreciate the real stories and often had to tone down my anger when I wrote about the conditions and the struggle.

My first character was Jenny, whom visitors would discover in the garden behind a tavern picking beans. I was not satisfied with the typical costume assigned to me by the foundation's costume department. With a full knowledge of the history, I added my own touches and decided that, as Jenny, I would not wear shoes, but would wrap my head in a scarf and smoke a pipe.

The following day, visitors might be greeted by my other character, Betty Wallace, a free Negro. As Betty Wallace, I would wear a proper dress, shoes with hose, and a big hat, and I would be seen sitting with a fancy dress in my big basket. Betty was a dressmaker for the aristocrats. She was sewing up a dress for Thomas Jefferson's wife and saving money to buy back her family and husband's freedom.

Clockwise from top left: In the 1930s, Ruth's grandparents moved to Newport News, Virginia, to work in a shipyard; Ruth's mother's aunts and uncle circa 1920; Great Aunt Mattie in the 1940s; Ruth's mother and aunt Evelyn in front of the family home in Hampton, Virginia, in 1980; Ruth's mother's cousins in 1940.

MALCOLM

DENZEL WASHINGTON

It became a day-to-day, living and breathing pursuit to capture the look of Harlem and the Nation of Islam.

Both Jenny and Betty were living in 1839. I presented compelling characters for the visitors. And as I projected my voice and began my two-minute monologue for the tourists, I would amass a large crowd. My picture was often taken. It felt real and it felt emotional. That experience encouraged me to look deeper into my history and to get very personal about it, no matter whose story it was. I graduated college and began a stint in theater with a continued love for period work.

It is no wonder, then, that when the opportunity came about to design my first period film, *Malcolm X*, I was completely ready for the task and knew the steps to creating authentic period stories through character and costume. It had been my passion for many years already. *The Autobiography of Malcolm X*, as told to Alex Haley, provided the basic outline that we were to follow. I dissected the book into five parts: early forties Roseland Ballroom, late forties Detroit Red, fifties Satan, sixties Malcolm X, sixties El-Hajj Malik El-Shabazz. These represented the five stages of Malcolm X's life, which were all rooted in very distinct time periods.

It became a day-to-day, living and breathing pursuit to capture the look of Harlem and the Nation of Islam. I studied them well, looking up the garments and comparing them to the actual photographs of people on the streets and in the dance halls. I went uptown to the Schomburg Center for Research in Black Culture, in Harlem, and delved into the library's photo archives. At 40 Acres and a Mule in Brooklyn, we moved out of the firehouse on DeKalb Avenue, where Spike's office was, and into a building around the corner on St. Felix. This would become the main headquarters for 40 Acres and a Mule. When we moved in, it was a vacated parking garage, complete with an elevator that carried cars up and down to the four floors and basement. This was very appealing to me, since we would need that elevator for transporting racks of clothing. And so we began the journey of crafting the Malcolm X experience there. Each floor was dedicated to one of the five eras of Malcolm X's life. The third floor was the fifties and the sixties. My assistant, Beulah, was the curator of this floor. It included all the Muslim suits and uniforms we would fit our background actors in. The second floor was for the forties. Zoot suits and Lindy Hop dancers and everything 1940s Harlem. The first floor was mainly shipping and receiving. We used the elevator to haul racks up and down, refueling the stock. The basement was dedicated to Malcolm Little's childhood—it consisted of everything from the 1920s and 1930s, including hoods for the Ku Klux Klan.

Another huge part of re-creating the life of Malcolm X was done at the close of principal photography in New York. A skeleton crew traveled to Egypt to re-create Malcolm X's journey to Mecca for the hajj. I was the only person in my department to go. This was a shock to my department, as they all thought they were a shoo-in to go. But it was only going to be me. I prepared a local Egyptian crew for my arrival, packing all the necessary Western wear from the film, including containers full of fedoras. The fedoras were part of our product placement from New York Hat Company. I soon found them very useful as

Costume sketch for *Malcolm X*

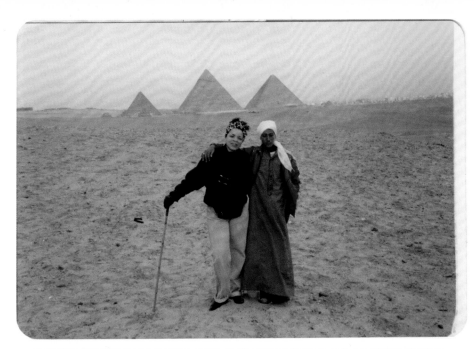

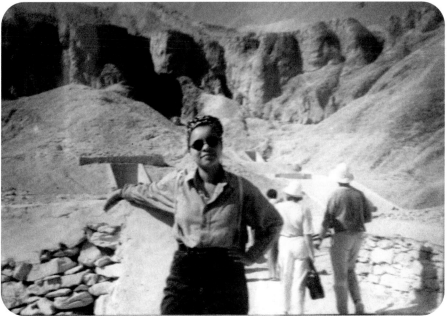

a bartering item after I arrived. The company drivers absolutely loved them. My driver slept in our car as it was easier than driving home and back. On my off days I had no problem at all getting around. I'd grab a few hats and head out. One day, in the old historic part of town, I was walking around with my hats on and noticed a vendor with a cart serving food. Turned out, it was fresh lamb used for falafel sandwiches. It was so fresh that the just slaughtered lamb was still on the cart. On the same outing, I paid for a rug, mostly with Egyptian pounds but ending a good negotiation with the gift of a new fedora.

The trip was fascinating. I recall the first day of filming was at the Great Pyramids. We were going to film a Muslim muezzin issuing the call to prayer at sunrise. We all loaded into vans at the hotel and traveled to the desert. It was still dark. When we arrived before dawn, I hopped out of the passenger van to look for the wardrobe van that I was assigned to. Off in the distance, it looked like the hotel had arranged a few tables covered in white tablecloths for our silver tray breakfast service. It was chilly out. I observed multiple local Egyptians crowded around the back of a small truck that was serving small glasses of hot soup. Nobody seemed interested in the American-style breakfast. I was too embarrassed to go near it. That day, I dressed Denzel Washington for his camel ride, along with the young men who were to portray his two guides.

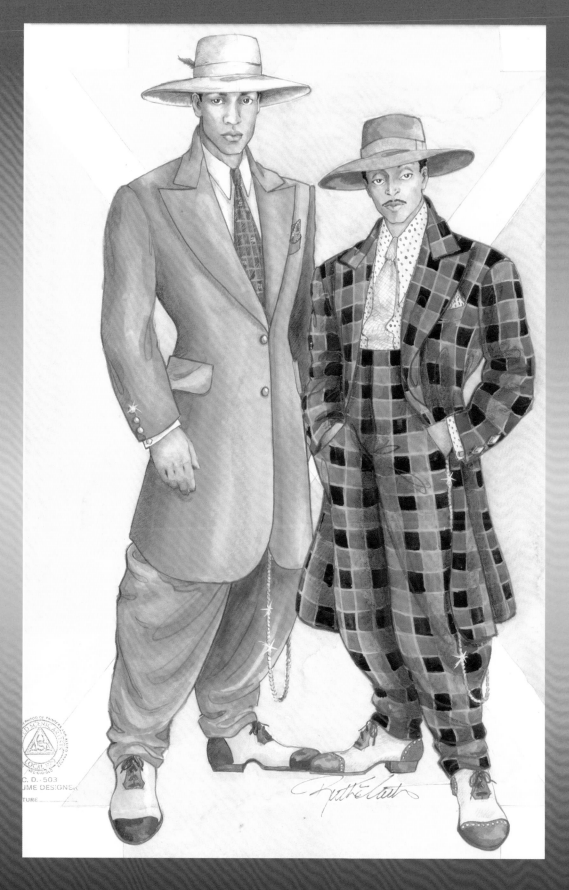

Opposite: Ruth on location in Egypt for *Malcolm X*

This page: sketch for Malcolm X (Denzel Washington) and Shorty (Spike Lee)

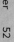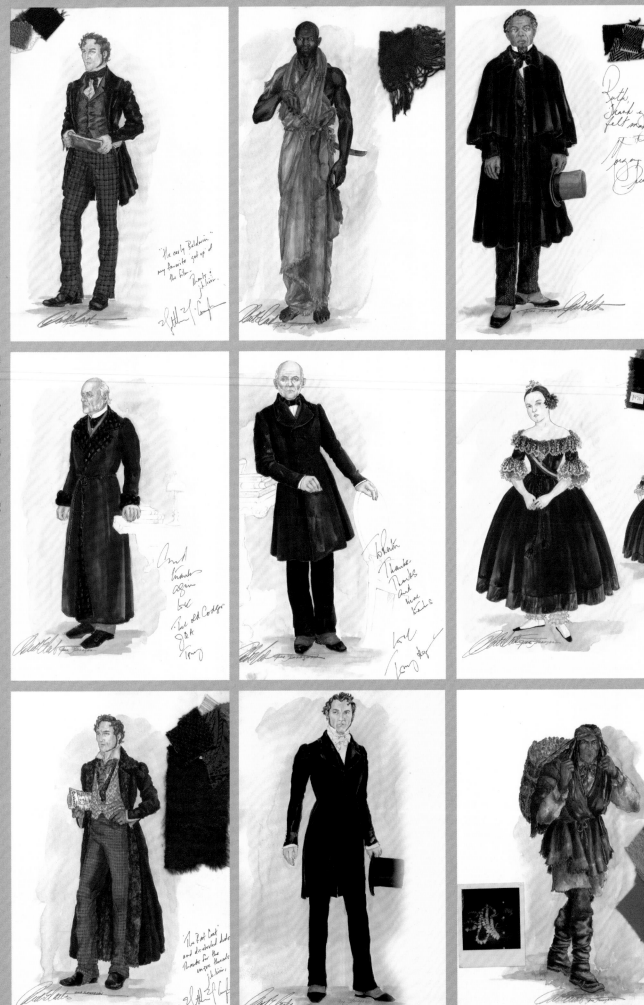

> **I politely thanked this big Hollywood director and left with my script. Only to call my agent from the parking lot screaming "Yes!"**

I received an Oscar nomination for *Malcolm X*, and my career took a big turn from there. I became a member of the Academy of Motion Picture Arts and Sciences. After becoming the first African American to be nominated in costume design, I was on a ride of period films—*The Five Heartbeats* and *Ty Cobb*, to name a couple. But the standout was the call from Steven Spielberg's office to interview for *Amistad*. The Black film community knew that he had teamed up with Debbie Allen to tell the story of Cinqué. The movie was based on the true story of the events in 1839 aboard the slave ship *La Amistad*, during which Mende tribesmen who had been abducted for the slave trade managed to gain control of their captors' ship off the coast of Cuba, and the international legal battle that followed their capture by the *Washington*, a US revenue cutter. The case was ultimately resolved by the US Supreme Court in 1841.

My interview for *Amistad* was with Steven Spielberg. I was excited to meet him. I had been told by another costume designer, also named Ruth, that he had told her he loved the work she'd done in *Malcolm X*. She politely said, "No. That was Ruth Carter." She then wondered if he had mistakenly hired her for the job they were doing together.

I had no script for my interview. They were not giving out the script, so I decided to buy cliff notes on the historical event.

I arrived at Amblin, a beautiful Spanish Revival compound on the Universal lot and the office of Steven Spielberg. I was escorted to the conference room where we were to meet. There in the room was a large conference table with all the chairs pulled away from the table and placed against the walls except for two chairs opposite each other. Assuming one was for me, I sat and set my notes on the table in front of me. Spielberg was shooting *Jurassic Park* on the lot and was meeting me during his lunch break. It was not a surprise that, when he walked in and sat across from me, a chef also walked in with a sandwich on a plate for him. Spielberg declined the food, looked at me, and said, "I really loved your work in *Malcolm X*."

Then we began to talk about this new project and the story of Cinqué's voyage on *La Amistad*. After a short time, he asked one of his assistants to give me the actual script. I took the two-hundred-plus pages, and then Spielberg said, "Take this home and read it. Then let me know if you would like to do it."

I felt like I could tell him right then and there. There was no need to go home to figure that part out. I had already been praying that I'd get the job when I first walked in! I politely thanked this big Hollywood director and left with my script. Only to call my agent from the parking lot screaming "Yes!"

Amistad was not an easy film to make. We were like a traveling circus, shooting on the East Coast as well as on the stages at the Universal lot in LA. I was happy that Debbie Allen was there to lighten my spirits. She was a producer on the film and had brought the idea of the story to Spielberg. I knew Debbie socially, but this was the very first time we'd worked together. She had a nickname for me: "Sun Beam." I guess it's because of the color of my skin. I embraced the love from her as I needed relief from many heavy days.

Opposite: Costume sketches for *Amistad*

I felt a strange and wonderful feeling of witnessing the beauty of time past.

Filming took place on a replica of the ship *La Amistad* located off the shore in Long Beach, California. It was difficult. Our base camp was on a huge barge, and we rode in small vessels to the large vessel to film. Steven Spielberg was a force. And there were a lot of moving parts involved in getting costumes out to sea if there were going to be changes.

Then a question from Spielberg came. "What is Cinqué wearing?" I was somewhat stunned. It was rare that he wanted information. The scene we were filming was of Cinqué returning to Sierra Leone. I was hard-pressed to give Spielberg a photo of Djimon Hounsou in his costume, because I did not have one. We were working on so many things all at once, and I had failed to take a fitting photo. And we were out at sea. I looked over at my assistant, Frank, and he was seasick, doubled over. But I always had research with me. I always referred to research photos when dressing background artists. I had a historic postcard with a painting of Cinqué's likeness in a royal-looking cross drape. I bolted onto a transport vessel to our *Amistad* sailboat. I approached Spielberg with the small image of Cinqué, and he smiled. I returned to our base camp, phoned back to my workroom, and informed them of the look, which they quickly put together and sent out to me.

I love being hands-on. It is part of my final process, the last stage of action just before things get on camera. I am very protective of that stage. It is the time when I get to interact with the cast and be a support to them. I groom and fuss and observe. Towards the last days of shooting *Amistad*, we traveled to Puerto Rico to film at the historic Castillo San Felipe del Morro. We were capturing the disembarkation of hundreds of slaves to the Americas and to a place where they were to be bought and sold. It was all hands on deck dressing many classes of people: auctioneers, Spanish sailors, slave owners, merchants, aristocrats, and many, many slaves. My team started very early in the morning, around 3 a.m. Depending on your character, you were directed to a specific section where an assistant costume designer was assigning clothing. Many of the more complicated looks had already been "pre-fit" days beforehand. A larger number of the background cast would be dressed as slaves and were being fitted on the day of the scene. It was difficult; it seemed like the most difficult body types to costume were in my line, and I had to explain through a Spanish-language interpreter that the ladies would be topless. It was a long morning. I took on the challenge of giving them more information about the story so they would feel comfortable. It was also so hot, even at that early morning hour, that most of them did not mind. As the sun began to rise, my line of troubleshooting was finally completed, and I sought to find my way to set.

This historical fort was massive and beautiful. It was built and then restored between the sixteenth and eighteenth centuries. As I walked around, it was not easy to find the film crew. I passed so many actors dressed in costume, speaking Spanish, and getting into character. It helped that I did not understand the language, because what I felt at that moment was not disrupted by contemporary conversations. I was tired from getting up so early and dressing people for four hours straight. I sat down on one of the benches and just looked around. I was the only one dressed in modern clothing. That is when I felt a strange and wonderful feeling of witnessing the beauty of time past. It was magical. The more I looked around this historical setting, without a crew present, the more it spoke to me: "This must be it."

Opposite above, center: Cinqué (Djimon Hounsou); **opposite below, center left to center right:** Theodore Joadson (Morgan Freeman), Ensign Covey (Chiwetel Ejiofor), and Roger Sherman Baldwin (Matthew McConaughey)

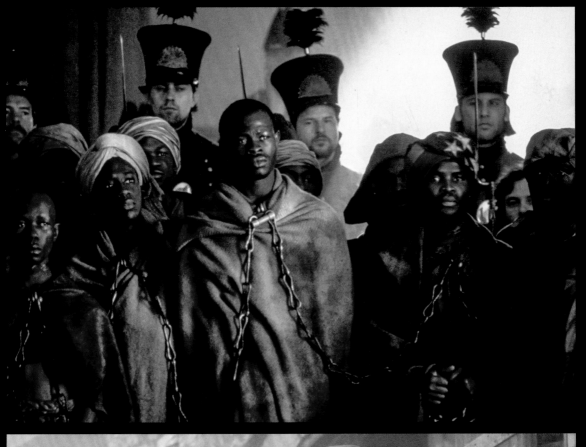

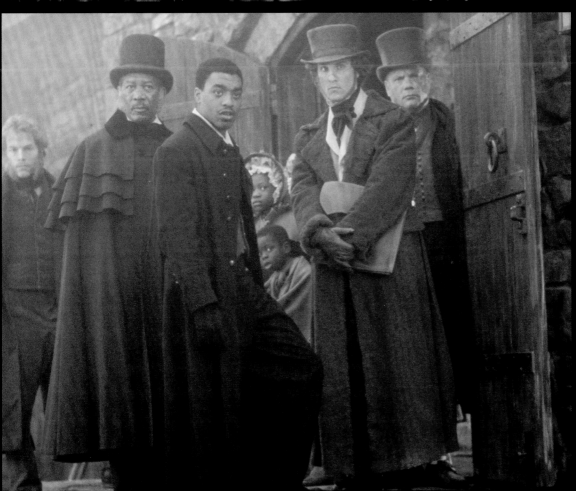

I felt like I was peering through a looking glass. I noticed the finely dressed merchants walking together. A man in a loincloth had a shackle on his neck with long pointed arrows coming out of it. He was tethered to the wall of the fort and pacing back and forth. I sat there for a while alone, mesmerized. I finally located the shooting crew, and Spielberg was well into capturing all the magic with several cameras very quickly. I was a little anxious after what I had just experienced, and very tired. But from that day forward, I had a profound sense of purpose to do whatever I needed to do to tell the truest story of my history.

Rosewood brought me together with John Singleton for the first time. We shot the film just outside of Orlando, Florida. This story was based on the actual events leading up to the burning of a fully functioning all-Black town called Rosewood, and it really reminded me of my grandparents in Virginia. They, too, lived in a segregated little town. I remembered it from when I was a small child. I loved working with Singleton; he was very kind. He had a special affinity for me, because I had worked with Spike Lee. But we grew to have our own special relationship. The period work on *Rosewood* was brutal. We were in the middle of the woods in a clearing where our two towns were built. Our base camp was on soft dirt, and it wasn't possible to roll racks without first laying down plywood from the wardrobe truck to the big tents where our background actors reported every day to get dressed. I loved this depiction of Blacks in the South in the early twenties. I was able to use an array of earlier time periods due to the characters' circumstances; the concept was that the characters never threw anything away. Clothing was handed down. I knew that sewing was a way of life for people during that time, who would often make their own clothes.

There was a particularly beautiful lace-and-cutwork collar, vintage and one of a kind, that I established on camera for a character called Scrappie. After reviewing the scene where it was worn, I realized it was too bright. It was "hot"

bright white. To continue to use it, I needed to carefully tone the color down by dipping the collar in tea. I did it right there on set, in the wardrobe truck. Then, I placed the collar between two paper towels to drain the excess moisture. In the middle of doing this, I was called away to set. When I returned to the truck several hours later to finish drying the collar, it was gone. I asked the wardrobe truck supervisor if she had seen it, and the color drained from her face. She had thrown the paper towels in the trash. Without panic, I walked to the trash. It had been emptied. When I inquired where the trash had been emptied, I was told it was in the large dumpster. When I went to the dumpster, the dumpster had been emptied. I couldn't believe it. I spent the next days re-creating this vintage handmade collar. I had enlarged continuity photos and screenshots of the collar given to me by the editors. I knew I couldn't re-create the lace—we were in the middle of nowhere. I had to come up with a close replica that had key elements of the collar, and the rest would be hand drawn with the detail. I managed to get it was the story of Ike and Tina Turner. The film was set mainly between 1950 and 1980. It was amazing to watch Angela Bassett prepare herself to play the part of Tina Turner every day. I was excited to put together the elements of the life of an icon.

While I felt at home with period work thanks to my theater training, I wasn't accustomed to working under a studio like Disney. I quickly found out how involved they were going to be. I'd been trained by Spike Lee, who was very accessible. When Disney sent me their notes for the first time, I was taken aback. They wanted me to cover more of Angela's incredible arms in the early part of Turner's career. I did it. But the notes kept coming. I never met the person sending the notes. And I was very confused.

I got through many hurdles throughout the shoot. Then one day, a production assistant (PA) jumped up onto my wardrobe truck and exclaimed, "Hey Ruth! Tina Turner is on set! Come, let's go to the set, and bring your photo book of all the looks

A production assistant jumped up onto my wardrobe truck and exclaimed, "Hey Ruth! Tina Turner is on set!"

you created!" I was stunned. I literally felt as if my feet were lifted off the ground with each step I took towards the set where the woman whose life I had designed in costume was waiting. Tina had, as expected, a flurry of people around her. I was shoved through the crowd by my PA friend, right up to Tina. I opened the continuity book to a random page. This book is the holy grail of every costume that is created and photographed in the film. She looked down at the book and then at me and stated, "I would *never* wear that!" I sank. She then kindly said, "Angela has a different body type than I have. I could never wear two pieces because of my long legs and short torso. Angela has a longer torso." I could breathe again.

Tina became an ally. She gave me actual garments from her collection for Angela to wear. And then one day she handed me a photo of herself taken during her "What's Love" tour. In it she was wearing a simple black leather dress with thin shoulder straps. She said in that distinct accent, "I want Angela to wear this tomorrow!" I swallowed hard. I took the photo. Then I bolted to the dressmaker we worked with, and she made the dress to perfection. Tomorrow came. Early in the morning I stood at the door of the wardrobe truck and watched Tina emerge, carrying a wig on a wig head, and head to Angela's trailer. She looked up at me: "Bring the dress to Angela's trailer!" I turned and went inside to get the dress. Tina had a few minutes' head start. When I got to Angela's trailer, I opened the door, and there they were: Angela Bassett sitting on the floor, and Tina Turner sitting behind her on the couch braiding her hair. The wig was up on the counter above them. She was preparing Angela's hair for wearing the wig from the tour. It was an image I will never forget. A queen preparing a queen to step into her role as a music icon. Incredible. Sorry, no camera phones back then.

Next two pages, clockwise from top left: mood boards for *Selma*; Ruth dressing one of the girls for the church bombing scene; Ruth dressing David Oyelowo as Dr. Martin Luther King Jr; Dr. King, center, with others

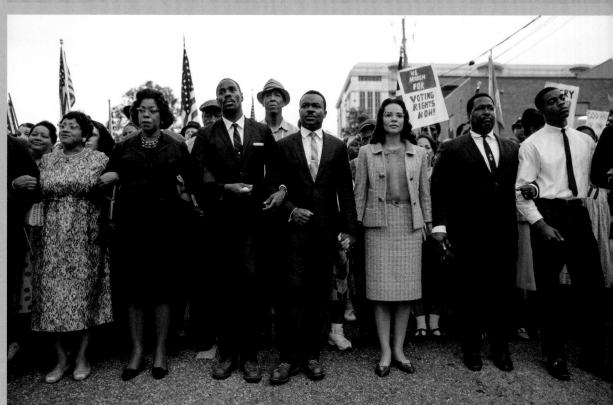

59 My Period Work

Opposite and above: sketches and final costumes for Sparkle (Jordin Sparks), Dolores (Tika Sumpter), and Sister (Carmen Ejogo) in *Sparkle*; **Next two pages:** Ruth with Eddie Murphy on the set of *Dolemite Is My Name*; costume sketches for *Dolemite Is My Name*

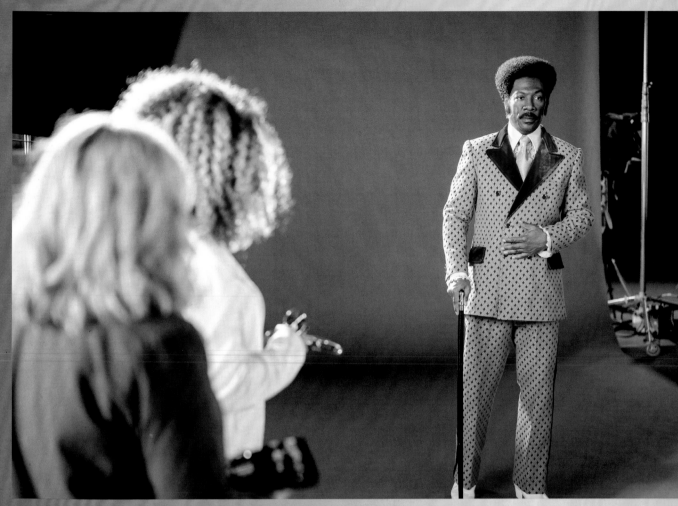

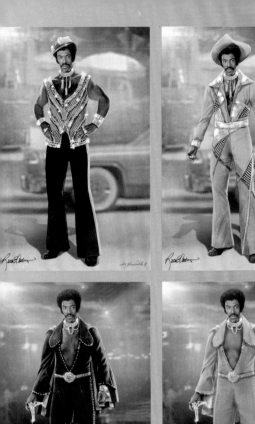
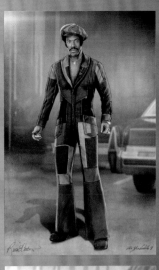
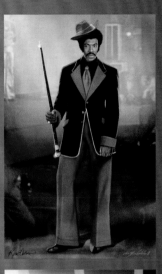
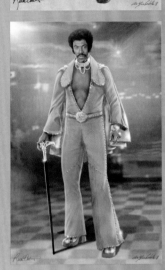
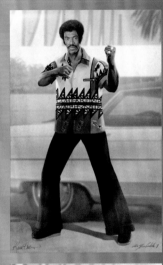
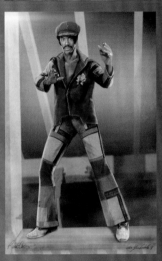
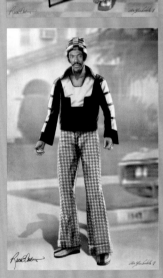
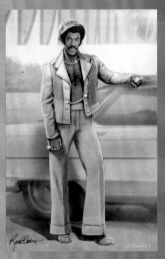
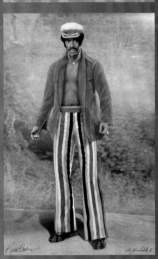
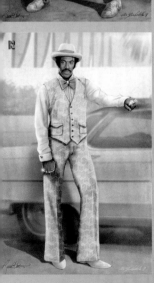
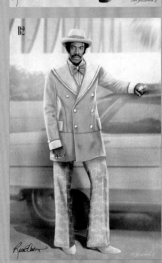
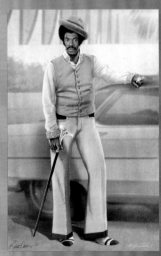
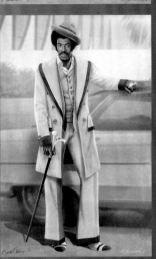

FROM THE COMEDIC TO THE SUPERHERO

C ostumes for comedic films are something that I have never shied away from. My work on superhero films started with the comedic superhero. Take *The Meteor Man*, for instance. I remember building the Meteor Man suit and being warned about how "real" superheroes were built. I didn't have a clue as to what they meant until later.

▲▼▲

Opposite above: Meteor Man (Robert Townsend) in one of his work-in-progress suits
Opposite below: Ruth with Luther Vandross on set

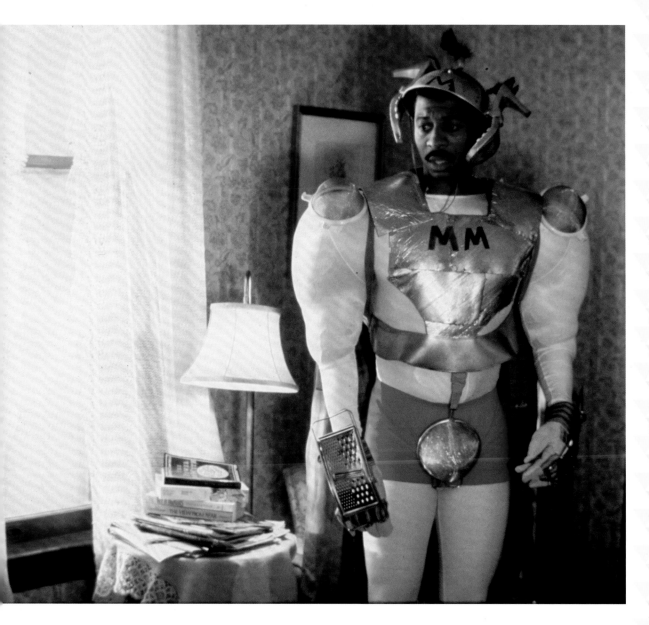

The Meteor Man

The Meteor Man, directed by Robert Townsend, was dubbed "an inner-city fairy tale." The costume was rather simple. Gray body, green cape. The emblem in the center of the chest was a meteor. Hence, Meteor Man. As the story goes, Meteor Man's mom makes the suit. Marla Gibbs plays the mother, and she makes several attempts before coming up with the hero suit. I think I had more fun coming up with the ideas for her failed attempts than I did designing the final suit. I sequestered myself in a workshop in Baltimore with a bunch of gadgets and soon realized this project wasn't going to be as fun as I had thought.

The gadgets gave me all kinds of challenges going together. It was a project that could have taken weeks with a little help, and I was attempting to make the three funny costumes by myself, over the weekend. But in the end, I did it, and the costumes *were* funny. It was hard, but it worked out.

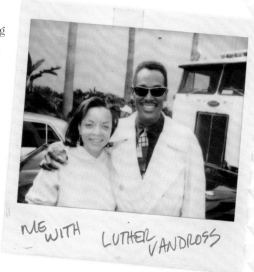

ME WITH LUTHER VANDROSS

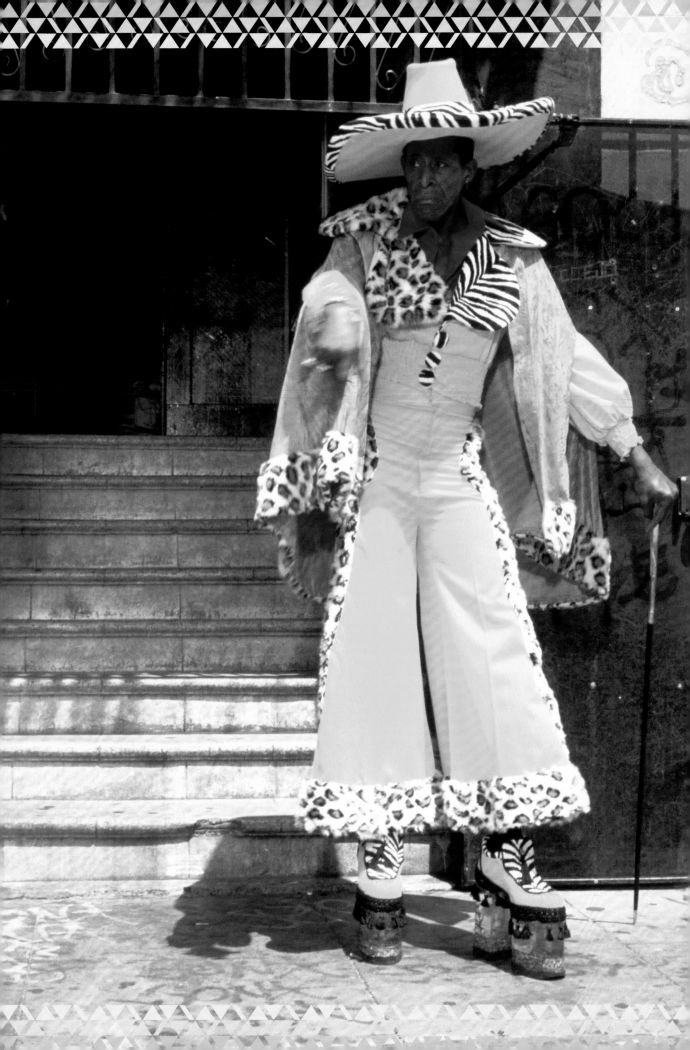

I'm Gonna Git You Sucka

In the independent film *I'm Gonna Git You Sucka*, Flyguy was played by Antonio Fargas, who in the seventies frequently played a streetwise pimp. The film has many hysterical pimp stories in it, but the one with the goldfish in the platform heels is the funniest. Flyguy returns to his old apartment after spending many years behind bars. When he emerges wearing his old pimp clothes, he's no longer the baddest cat on the block. He is now a laughingstock. He's wearing all yellow with animal-print-trimmed bell bottoms and a cape. His hat is yellow, too, and gigantic. Then you see that there are goldfish inside the platform soles of his shoes. As he tries to escape the laughter, he breaks a heel, and the fish comes flopping out onto the ground.

Black Dynamite

Black Dynamite came about during the recession in 2007. I did four independent films that year, and this was one of them. It was shot entirely in Los Angeles, but that didn't make it any easier. Because it was an independent movie, I handled a lot of costume duties that I normally delegate, including carving a life-size donut costume out of foam in my backyard. I had to ignore the strange looks I got from my neighbors; I could read the questions on their faces about exactly what I did for a living. And again, there were pimps. Arsenio Hall, Brian McKnight, Cedric Yarbrough, and John Salley were pimps with names like Tasty Freeze, Sweet Meat, Chocolate Giddy-Up, and Kotex, and Tommy Davidson played a character called Cream Corn. It was a crazy movie to work on after having bridged my career from independent films to studio films. Coming back to an independent production was a way to train new people and a reminder of the skill set I had left behind. There were experiences, such as walking from the parking lot at the start of the day with an actor excited about a costume you had no idea had been added, then making the costume in the wardrobe truck the same day. This film was a special challenge. And fortunately for me, the cast and crew were like a family, and supportive.

Flyguy (Antonio Fargas) in *I'm Gonna Git You Sucka*, wearing his iconic goldfish platform heels.

Meet Dave

In *Meet Dave*, Eddie Murphy stars as a live robot. My thoughts were to make him a good-looking robot with a solesker style. So I tailored his white suit with flared legs and cuffs. The film was not a success. But all the characters in the film had a futuristic feel, including Gabrielle Union in her space suit, and a host of other ooks and characters in futuristic costumes.

Daddy Day Care

For *Daddy Day Care*, the carrot and broccoli costumes were a lot of fun to create. The director, Steve Carr, didn't expect these larger-than-life costumes to end up as funny as they were. Even though I presented him with a costume sketch, it didn't have an impact on him until our actors were wearing the costumes in the first camera test. We sat together in a dark theater with all the other department heads, and I heard someone laughing hysterically a few rows behind me. It was Steve. He laughed at everything about it—the red rubber band and the broken stalk. I thought to myself, I've really done something that was from my imagination, and it's a hit!

Bamboozled

Bamboozled reunited me with Spike Lee. I was designing *Shaft* at the time, but I worked out a deal with Spike so that I could do both films. We had fittings in my Manhattan studio office, and I set up a workroom at 40 Acres in Brooklyn. The minstrel shows were built in Spike's Brooklyn office. I planted my feet for the last time at Eaves-Brooks to pull the vintage pieces I needed. Eaves-Brooks was a family-owned costume rental company founded in 1863. Its clients included theaters, schools, churches, and universities. Walking into that place made an impact on me, for I could feel the presence of the many performers who had occupied the costumes. And it felt real to me to pull the minstrel-show pieces from there, because that's where some of them were born. There was one costume in *Bamboozled* that stuck out to me. We were shooting on the Apollo Theater stage, and Savion Glover was dressed as half Manray character and half black crow. It was so uncomfortable to watch on stage, even though I was very happy with the way it was made. It just felt too real. It hit home. And we all never wanted to see that costume again.

WE SAT TOGETHER IN A DARK THEATER WITH ALL THE OTHER DEPARTMENT HEADS, AND i HEARD SOMEONE LAUGHING HYSTERICALLY A FEW ROWS BEHIND ME.

FROM THE BEGINNING, THEY WANTED TO HAVE FUN WITH THE WARDROBE.

B.A.P.S.

Halle Berry and Natalie Desselle Reid starred in *B.A.P.S.* From the beginning, they wanted to have fun with the wardrobe. When I read a pivotal scene in the script, I knew I needed to work backwards from that moment to start Halle's character out. It was a scene where the two girls are introduced to a mansion for the first time. They enter the bathroom and are curious about what the bidet is for. Halle's character thinks it's "for number one." As she attempts to demonstrate how to flush, it becomes a scene that is out of control when she can't turn the faucet off nor catch her balance. That's when I thought the catsuit she'd have on in the scene would be made from latex. And it worked!

Sketch of Mickey and Nisi from *B.A.P.S.*

LEGENDARY ACTORS

have had the pleasure of working with some of the most talented actors in the industry multiple times. I've worked with the great Eddie Murphy and Samuel L. Jackson on seven and eight movies, respectively, each very different from the next. I've dressed the fabulous Angela Bassett in six films: *Malcolm X*, *What's Love Got to Do with It*, *How Stella Got Her Groove Back*, *Chi-Raq*, and two *Black Panther* movies. I've worked on four films with the wonderful Halle Berry—*Jungle Fever*, *B.A.P.S.*, *Frankie & Alice*, and *Kidnap*—and two films with the late, great Chadwick Boseman: *Marshall* and *Black Panther*. Although some of these films were not high-grossing, the character-building was far-reaching and worth an analysis of these actors as a group.

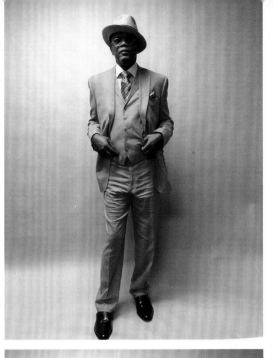
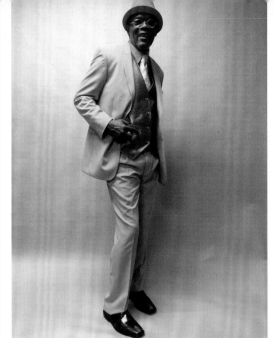
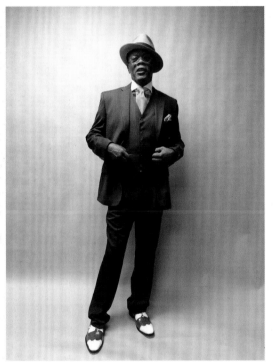

Samuel L. Jackson

Samuel L. Jackson. A great actor. Dressing Sam for eight films is like ripping your favorite chapter out of *Theater Crafts* and utilizing every theater course on character-building you took in college. He's a consummate professional and a risk-taker. Our journey together started on my very first film, *School Daze*, where he played a local yokel—a term of endearment, to say the least, given to those neighborhood guys who lived in the hood surrounding most Black colleges. Sam plays character roles so well; he embodies all the details that you as a costume designer put into his costumes. Now, let's see those details. I dressed him as a crackhead, complete with an army jacket and a Bulls cap (*Jungle Fever*); a loan shark in tacky polyester digs (*Mo' Better Blues*); the "Love Daddy" DJ with colorful hats and neighborhood flair (*Do the Right Thing*); Dolmedes giving you all the love that a Chicago-style Dandy can offer (*Chi-Raq*); a boxing promoter called Sultan, with his own crowd-pleasing gimmicks of turbans and fancy suits (*The Great White Hype*); the owner of a prison that was avant-garde and strange (*Oldboy*); and the sex machine known as Shaft in the signature black leather jacket and black turtleneck (*Shaft*). I couldn't ask for a better specimen and person. He absolutely loves when you get creative. Sam has so many films to his credit—I'm proud to have had the opportunity to slide in between the big tent-pole films and dress the superstar, my way.

Samuel L. Jackson at a costume fitting for *Chi-Raq*

Eddie Murphy

The journey with Eddie Murphy was very different than the one with Sam. I worked with him on *Dr. Dolittle 2*, *I Spy*, *Daddy Day Care*, *Meet Dave*, *Imagine That*, *Dolemite Is My Name*, and *Coming 2 America*. The challenge is to get it perfectly right without a lot of fittings. I learned to measure him well the first time and fly from there. Eddie is less concerned about the clothing. I think he trusts me. My first film with him was *Dr. Dolittle 2*. I was already a huge Eddie Murphy fan from all his movies and *Saturday Night Live*. I was excited to have the opportunity to step into a "mainstream" film experience and dress such a legendary super talent. Eddie Murphy supported me in so many ways. My film experience with him became much more elevated than before. I was working on studio films with a mega talent. I had the ability to explore more ideas, because his films had bigger budgets, as well as having the endorsement of a celebrity like Eddie Murphy, which goes a long way. It takes a big movie star who "gets it" to support a Black woman trying to move through the Hollywood system, who is simply doing what anyone else is doing, with the same amount of talent. *Dr. Dolittle 2* was a conservative-looking film about a veterinarian and his family. It may have seemed to be a walk in the park to some, but the Eddie factor was the challenge. As I was getting to know his likes and dislikes, I kept a journal noting his sizes and preferred fabrics, socks, underwear, shoe styles, etc. I put him in the best clothes money could buy. But I soon learned that in the time it took the animals to walk from cage to cage, and the time it took for Eddie to arrive from home, I could do a whole other film. So, I dashed across town to dress Tyrese Gibson as the title character in John Singleton's *Baby Boy*. What an adventure in costume design. An African American superstar in Beverly Hills and another in South Central Los Angeles. The two sides of the African American journey in Hollywood.

For *I Spy*, Eddie and I traveled to Budapest, where I dressed him as a prizefighter. The September 11 terrorist attacks hit while we were in Hungary. Luckily, I had packed all of Eddie's clothes in my suitcases and very few of my own. I knew his clothes were too unique to risk letting them get stuck in customs or grounded at the airport. And I was right. In *Meet Dave*, he was a larger-than-life robot. I loved the suit I made for him. I thought he looked amazingly handsome in it. In *Daddy Day Care* I dressed him as a human-size broccoli. In *Imagine That*, I made him a superhero costume out of an everyday business suit complete with a crown made from binder clips. In *Dolemite Is My Name*, the costumes were honoring the comedian Rudy Ray Moore and were over the top in the period seventies style. Eddie and I are about the same age, so we both remembered a lot about the seventies. It was fun to joke around with him in the beginning. Then his platform shoes started to hurt his feet while we were filming. I wanted to say, "Yeah, I remember that too." But it wasn't funny at all to Eddie. We ended up letting him wear his tennis shoes when we weren't seeing his feet in the shot. And lastly, there was the king of Zamunda, Prince Akeem Joffer, in *Coming 2 America*. We had the lion he wears on his shoulder printed by a 3-D printer. Eddie Murphy has been an absolute dream to work with. I still pinch myself in his company.

Eddie Murphy as Prince Akeem in *Coming 2 America*

> ## It takes a big movie star who "gets it" to support a Black woman trying to move through the Hollywood system.

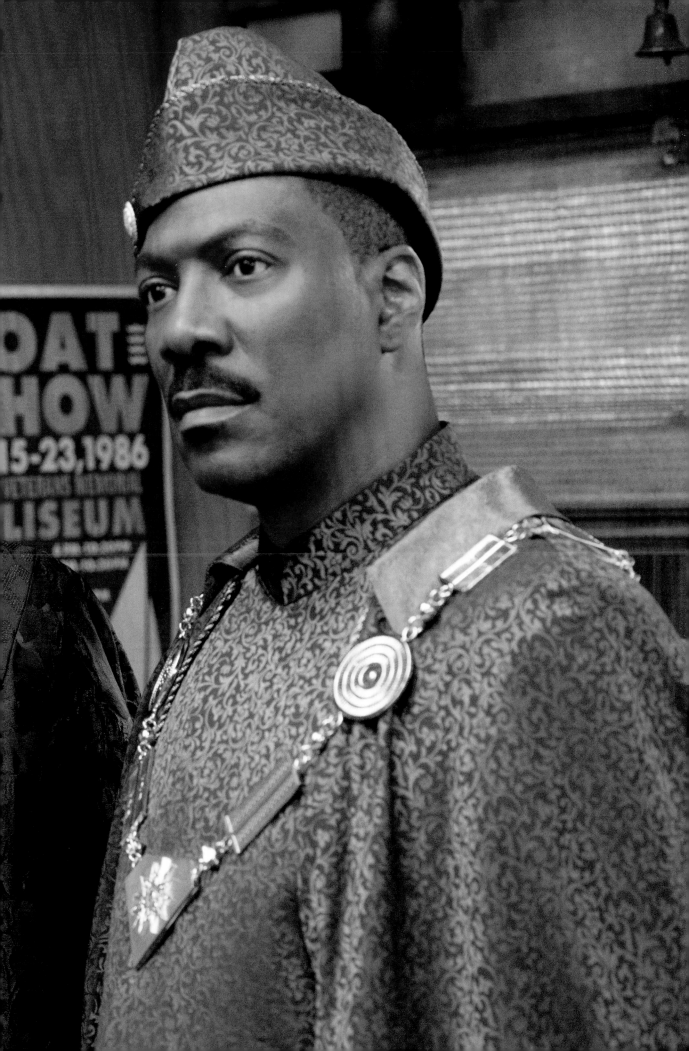

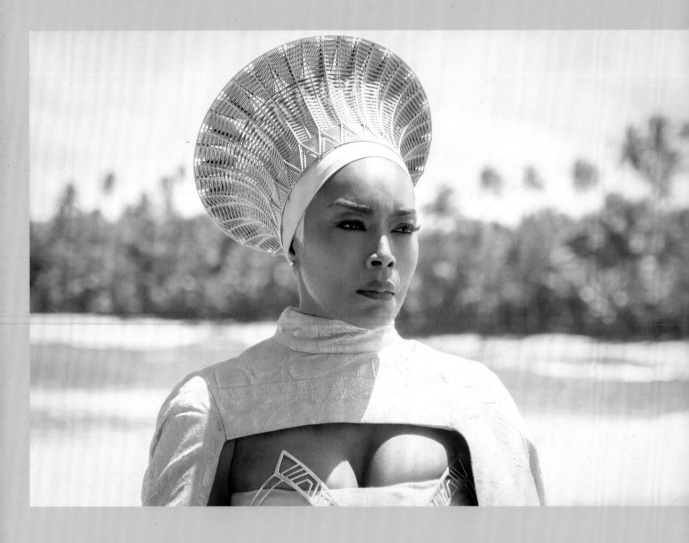

Angela Bassett

Angela Bassett was introduced to me when I was the costume designer for the Tina Turner story, *What's Love Got to Do with It*. I remember seeing her at the camera test for the film and witnessing her commitment to her craft as she got into character off to the side. The journey I've taken through the years with this actress was truly meant to be and supports the sisterhood of artists. When the Hollywood casting couch and the #MeToo movement rolled out, it was no match to the unwavering talent and strength of characters that this formidable actress portrays with her body of work and as a role model. Just look at how she embodies the character of Tina Turner in her signature gold-fringe dress. Witness the calmness of Betty Shabazz in *Malcolm X*. Find yourself personally relating to the journey of Stella in *How Stella Got Her Groove Back*. *Chi-Raq* was a protest film, and *Black Panther* was the most culturally relevant paradigm-shifting film of the decade. The journey of connecting this woman's talent to her costume has been mind-blowing.

Angela Bassett as Queen Ramonda in *Black Panther: Wakanda Forever*

i HAVE HAD SO MUCH FUN DRESSiNG UP ONE OF THE MOST BEAUTiFUL WOMEN iN THE WORLD, iNSiDE AND OUT.

Halle Berry

Then there's the undeniable bravery of Halle Berry, a woman who defies her own flawless beauty to pursue a deep commitment to the work of an actress. She gives herself up to portray the utmost authentic characterization. Mentally and physically, you can see it on her, to the point that you forget it's even her. I've gotten to know this about Halle: She is committed. From a drug addict in *Jungle Fever* to the witty character in *B.A.P.S.* to a psychedelic stripper/ Southern belle in *Frankie & Alice*, I have had so much fun dressing up one of the most beautiful women in the world, inside and out.

Chadwick Boseman

My journey with Chadwick Boseman on two films is one that I will forever cherish. I read somewhere that he connected with Denzel Washington as an actor; in my mind that confirms the fate that brought him into my scope. I, too, connected with Denzel's amazing process and dedication. We journeyed together through *Malcolm X* and *Mo' Better Blues*. Both of us are full of passion for our different crafts, and the collaboration between filmmakers was magic. I witnessed that same commitment in Chadwick, and it was remarkable.

I was hired as the costume designer on the film *Marshall*, in which Chadwick was playing the lead. As I was prepping the film, I was tracking an interview I'd done for *Black Panther*. I was feeling a little superstitious about it but couldn't help but be in awe of the fact that not only was I presently working with Reginald Hudlin, who wrote one of the highest-grossing *Black Panther* comic books and invented the character of Shuri, but I was also dressing the lead who would portray the Black Panther himself. It was a perfect storm that I was afraid to touch until I heard back from my agent that the job was mine. Until then, I didn't want to utter a word.

Then, on our first day of shooting *Marshall*, I drove to base camp and took a call from my agent before getting out of my car. I was selected to design *Black Panther*. I was thrilled, petrified, emotional, and floating above ground all at the

same time. I thought, I still haven't developed a bond with this actor, Chadwick Boseman. We have yet to go on our first journey, building the bond between costume designer and actor—the same connection that I forged with Denzel and the rest. I didn't want to introduce the conversation about the second project without having the first one under my belt. So, I decided to not mention my getting the job to Chad until I felt confident that we were a successful duo. So, I waited. I groomed his character. I worked on our compatibility. I entered his trailer one day to present the new costume change that was hanging there, and he said, "You killed it on this!" That's when I thought, Okay, now would be a good time. I said, "Well, I didn't want to say anything before now, but I guess I'll see you on *Black Panther*." We were well into the last week of filming, so I felt good about saying it then. Chadwick gave me that big bright smile of his and said, "Ruth, I already knew!"

Keeping that bright spirit was what gave me the joy of working with Chadwick on *Black Panther*. He was patient as we worked together on so many looks for T'Challa. And he was sometimes funny. He would make me laugh all the time when the costume was leaning more towards the Commodores than the leader of Wakanda. I would agree and start over.

Chadwick Boseman at a costume fitting for *Marshall*

CHADWICK GAVE ME THAT BIG BRIGHT SMILE OF HIS.

was in New York doing press for *Roots*, a reboot of the 1970s classic, when I was informed that I had an interview at Marvel Studios with director Ryan Coogler and Marvel executive Nate Moore. They were interested in talking to me about their new film, *Motherland*, the story of the Black Panther. (*Motherland* was the pseudonym for the *Black Panther* film while in the planning phase of production. It was no secret that many were anxious to see this film get done, and it was important to protect the intellectual property from being exposed to the public.)

My first reaction was, "Was it the Black Panther Party?" I soon received a dossier of materials, including a copy of a few pages from the comics, and a short blurb about the place called Wakanda. But no script. I was concerned, because I knew very little about Wakanda and the Black Panther and had no storyline to help guide my preparation for this important meeting. I grew up as a comics fan like most kids, but my weapons of choice were *Little Lotta* and *Archie*. My brothers had Spider-Man and Black Panther comic books in their room, but I could never read a single one, since their comic book collection was seriously off-limits to me, the little sister.

When I was summoned from New York, I got on a 5 a.m. flight back to Los Angeles. It was raining in New York when I left my hotel at 3 a.m., armed with the material I'd been given.

A River Tribe Elder (Isaach de Bankolé) in Wakanda

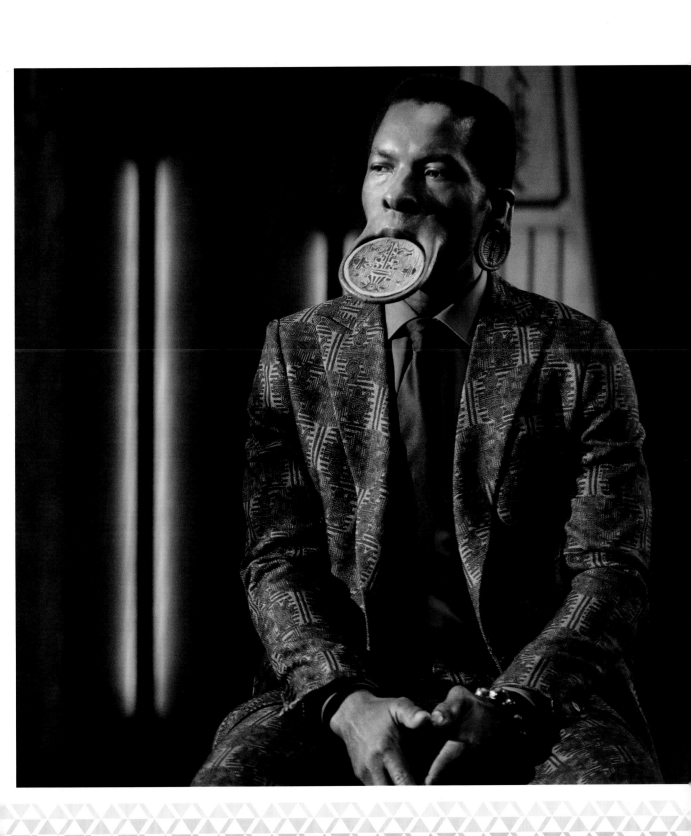

The idea of combining hard science with technology and then fusing that into an African aesthetic felt exciting and challenging.

Reading the material on the flight, I was fascinated, as well as intrigued, since I felt I had a long way to go to really understand the long history of this world. Who is Ulysses Klaue? What is vibranium? Where will this story start? It wasn't something I was going to learn completely during the course of the flight. But I did my best to cram!

I landed in Los Angeles and immediately called a friend, illustrator Phillip Boutte Jr. Phillip works with many costume designers on big superhero films. He researches and aids in creating the designer's vision through the illustration process. The perfect ally. As I suspected, he knew a lot about the character and had heard about the possibility of the movie happening. He immediately began sending over images to help my understanding of Afrofuturism in cinema. The images reflected Afropunk and African aesthetics mixed with hard science. My interview was that afternoon, and I wasn't sure what to prepare. So, I relied on my friend to help me amass a Dropbox full of images that I edited. As I thumbed through the images, the concept of Afrofuturism felt very recognizable and relatable. I felt like I knew this concept, as it had played out many times throughout my life— whether as a child of the Black Panther political movement in the sixties or of the neo-soul genre in the eighties. At the same time, it wasn't like anything I'd done before.

The idea of combining hard science with technology and then fusing that into an African aesthetic felt exciting and challenging. I just wasn't completely sure I could nail concepts by that afternoon.

I entered Marvel Studios, and it felt like what I imagined the CIA might feel like. The whole place was bright white. There were buzzers and intercoms with voices asking who you were there to see. My photo was taken at the reception desk, much like at an eye exam, and I thought maybe they had actually scanned my retina. I was escorted to rear offices and through another set of passcode-protected entries to finally meet the warmest guy ever, Ryan Coogler. At first glance, I wanted to hug him like a brother or son. He felt real, and his eyes had so much depth.

That alone, unfortunately, didn't necessarily calm my nerves—that feeling you have after cramming the night before a big test, when you're praying every minute that you're ready. I was frightened that I might be quizzed on Black Panther history or the uses of vibranium. I sat down nervously and opened my laptop. Soon we were joined by Nate Moore, the producer. We exchanged greetings, and I got on to the internet. I tried to open my Dropbox, and it just would not open. I felt paralyzed and panicky. I was relying on sharing the images with them, and it wasn't happening. At that point, I was multitasking, my attention split between listening and worrying. My images were stuck.

Then Ryan said to me, "Ruth, I really loved your work in *Malcolm X*. I was a young kid when my dad took me to the movies to see the film. I remember that the costumes had a lasting effect on me." I was stunned by his words. I no longer felt like an outsider. My senses readjusted, and I felt proud in that moment and wanted to gift this young filmmaker my costume knowledge of

thirty years, the things I'd learned about having purpose in your work. But it was evident that he had purpose, the same way we did in the beginning on a Spike Lee Joint. I thought maybe the stars had aligned between me and this young filmmaker when he was a boy on his father's lap, decades before we would ever meet. Nate then walked out of the room and came back with his personal computer. I finally logged in with his help and began to share my favorite images. There was a feeling of sameness, purpose, and intention that I never forgot as I went on this very special journey.

But creating costume designs for Marvel comes at a price. It's an experience that's not for every costume designer. When you sign on to their high level of collaboration and their mission regarding the direction of their heroes, your assignment is to integrate yourself into the well-oiled machine of the Marvel system. You will be greeted, on day one, with costume-design renderings for their superheroes, and you might wonder if you were hired for the right job, as a fully capable costume designer. For years, Marvel has done concept-design development, before you or anybody else comes on board. They render "character design." This is a part of the bigger picture at Marvel. It connects with Marvel-licensed toys, games, you name it. So, they are busy at work. And I actually thought it was a cool idea. It took the edge off. Since I had never designed a superhero film before in my life, I welcomed their top-level involvement.

When I finally read the script, I knew that there was a whole new world to create around the costumes. The Wakandan world-building was foreshadowed in a document created by the production designer Hannah Beachler. It was referred to as the "Wakandan Bible." This large document outlined everything about Wakanda: the transit system, the various districts, the evolution of the city, and the names of the Wakandan tribes, as well as which African tribes they were inspired by. This was invaluable to me, since I felt that I had come on to the project so late in the game. Everyone else seemed to have a head start, but this was the information I needed to get the ball rolling. It was a welcome relief to stick to what I knew: Black culture and the African diaspora.

I immediately asked my staff to study Hannah's document, and we started to create inspiration boards based on real images of the tribes that inspired Wakanda. The boards were displayed on the walls throughout the department, and I reviewed them every day, gleaning information on traditional African style and ancient indigenous cultural dress.

With the assistance of very talented illustrators, I developed a first round of design ideas for Nakia, the palace guards, and the tribes. These illustrators, who were more familiar with the level of design output that the Marvel executives were accustomed to reviewing, got on to it right away. It was a bit tricky to work with four skilled artists at one time, because every artist has their own style of working and creating. In the past it had been a one-on-one scenario—me and one illustrator working together for a few weeks. That was it. Now I had a team to guide, with their own pace and their own skill set. You have to meet in the middle. If you want them to communicate your aesthetic properly, you need to be informative, adding your input on every element of the design. I began using the inspiration boards, lining the illustrators' office with them and putting notes on the images that I wanted them to focus on.

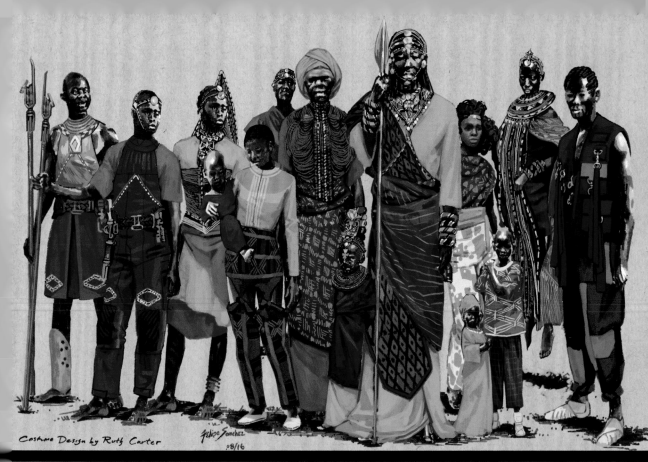

Costume Design by Ruth Carter

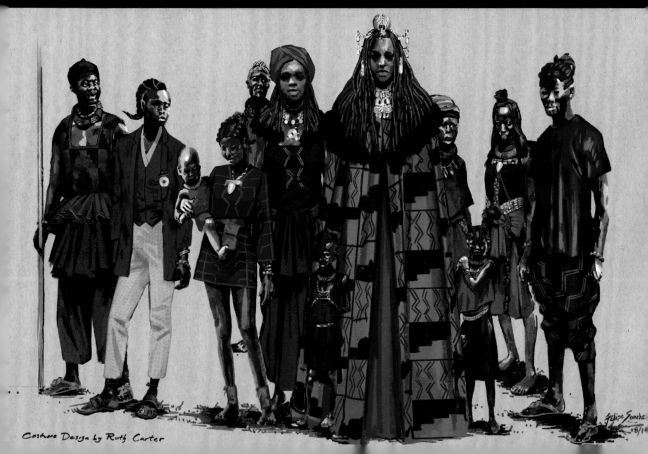

Costume Design by Ruth Carter

WHEN THE STORY TAKES A TURN, YOU TURN WITH IT.

They produced great work. I was relieved to see the high level of illustration coming out of my department. I would then take their work and put it together myself in presentation form.

I invited Ryan Coogler over to my office to preview all the mood boards and illustrations we had amassed. He arrived and looked around. After he left, I felt a bit of a disappointment. I had hoped to be impressive, but it didn't feel like I had excited him at all. I edited my presentation. The first presentation to Marvel was in a large conference room. In attendance were Ryan, Nate, and Hannah; a trio of Marvel executives affectionately known as the "Three Amigos": Kevin Feige, Victoria Alonso, and Louis D'Esposito; and a head from each department, including Ryan Meinerding, the Marvel development guru and master illustrator. My presentation was short, because I had edited so many things out of it. I didn't want to show up with ideas that I thought Ryan Coogler did not want me to show. It's sort of an unwritten rule: When the director says,

"I didn't see it that way," out it comes! After my edited presentation, Ryan exclaimed, "Where is the rest of it?" I replied, "I didn't think you wanted them included." Luckily, that day in my office we had given him a hard copy of everything. He asked his assistant to run to his office and grab the big portfolio. He returned, and everyone gathered around, commenting on many of the costume designs I had to offer. It was a very difficult room to read. At times I couldn't tell if I should start over or not. But I relied on my instincts. The more I listened, the more I adjusted and fit each design into the overall picture. It's really a process of learning and understanding that we are all in it together. When the story takes a turn, you turn with it.

Designing the costumes on paper for *Motherland* was only the beginning. There is an additional design process of materialization and implementation. You must be able to imagine the finished product and make decisions on many details to bring it to life.

Costume sketches for the Wakandan tribes

T'Challa/The Black Panther

Chadwick Boseman

The Black Panther suit is a "specialty-costume design": a costume that has molded elements and is shaped into a one-of-a-kind form. Computerized machines produce physical materials from the design, whether via 3-D printing, molded elements, or special raised prints.

They also require the work of many hands, including companies that are solely specialty-costume builders. These companies make sure the physical materials look and move just as the designer intended. Working with Ryan Coogler, Marvel, and a very talented group of assistants and concept artists on this suit was one of the most incredibly creative experiences in my life. My part began with collaborating on all of the design elements and ended with making it all come to life!

But I had to learn the process that goes into building a superhero suit. A lot of it was like learning a new language. There was a special fabric used to make the suit called Eurojersey. We selected a pattern that we called the "Okavango triangle," named after the Okavango River in southern Africa. The triangle's three points also signify the mother, the father, and the child in Africa, making it a sacred geometry.

Chadwick Boseman came into my office to try on his first Black Panther suit, which he had worn in *Captain America: Civil War*. I was curious about the "super suit." Since this would be my first experience building a new one, I wanted to see just what made these superheroes tick. I'd had this first suit on a mannequin in my office for a couple of weeks prior and frankly didn't see what was the big deal. A black textured suit with a mask. I greeted the suit on the form every day and had lots of ideas about the surface textures that could be used. But standing there on the mannequin, it had no life. Chadwick arrived as usual after a workout. He was cordial. It took a couple of people to help him get into the suit. It's made of Eurojersey that has been printed on to create not only texture but also many design details, which are added to the thin top layer. Under the Eurojersey layer, there is a muscle suit that is put on first. Once Chadwick was all zipped up into the suit, he added the helmet and began to move around ever so slowly, bending and stretching in the martial arts Black Panther poses. I was stunned. He was as majestic as a real live panther would be! I was so excited and reacted with great enthusiasm. Then he stopped, stood upright, turned to me and said, "Well, I can hardly breathe out of my nose in this helmet, and it's very hard to lift my arm." Smash cut back to reality. I knew then that we were going to make the new suit to at least give him those abilities.

We built that suit. It was simpler than the first, complete with silver vibranium muscles that gleamed through the top layer. The Okavango triangle did not disappoint and traveled around the suit like faceted gems. However, we weren't without our own set of problems with the suit. The Okavango layer was so thin that it blew open in the seat every time the stuntman wore it. It was at this point I decided to make a "tough suit" made of a double bonded Eurojersey that could withstand the abuse. We called in a cutter from the Boston Ballet to create special gussets under the arms in those places where it would need more stretch. We were able to save the king of Wakanda.

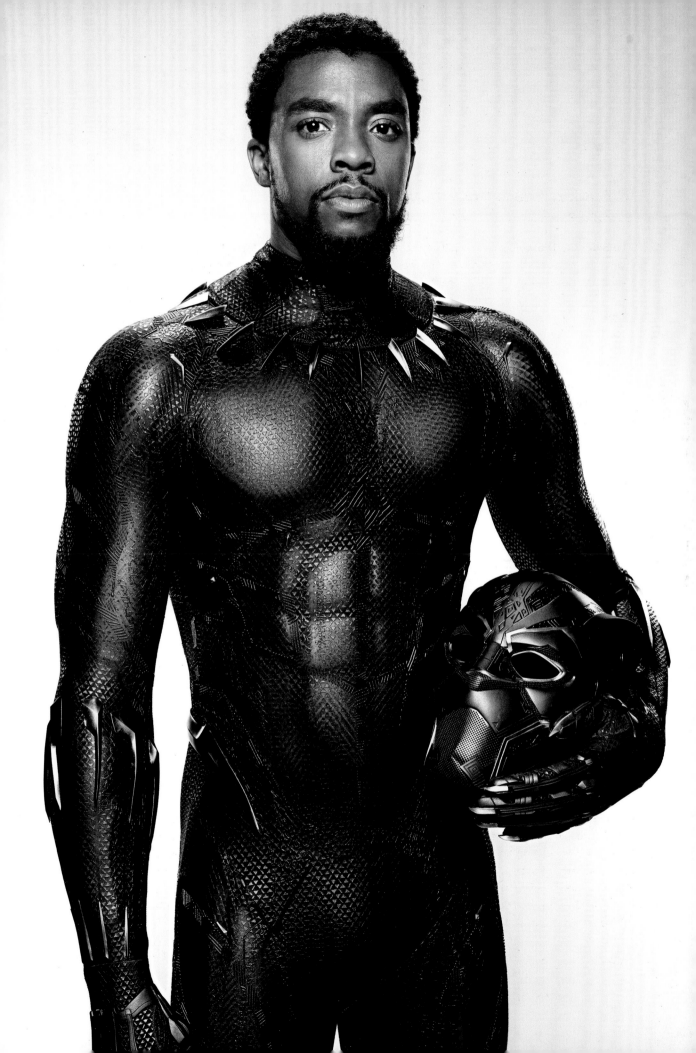

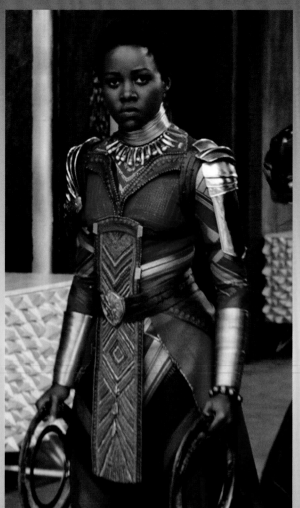

EACH PIECE OF TUAREG JEWELRY HAS A SPECIAL MEANING.

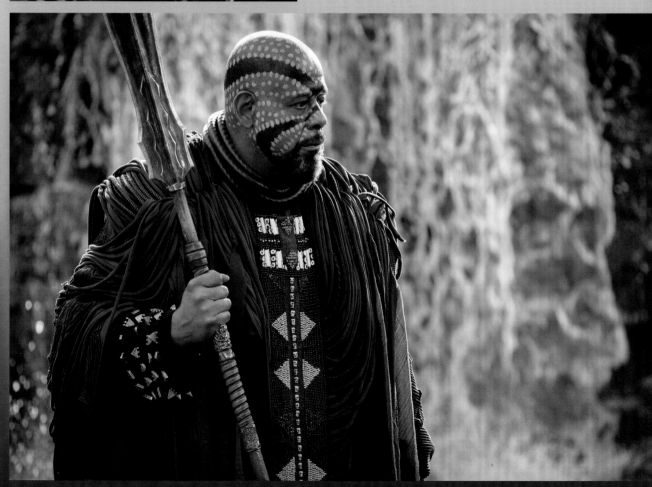

The Dora Milaje

The Dora Milaje's spears and the gold and silver jewelry armor are laced with silver vibranium, the strongest resource in the universe. The other tribes show similar vibranium features in their weapons and clothing.

As I began building the Dora Milaje costume, it included a leather harness with a vertical beaded tabard. I wanted the harness to have meaning, to be African, and to look like maybe it was passed down to each Dora. If the harness was going to be so prominent on this warrior costume, I wanted it to travel around the female form, honoring the body of the woman while protecting her. Beadwork in African cultures has always had a strong impact and distinction. The character of Okoye, played by Danai Gurira as the general of the Dora Milaje, inspired the importance of being authentic with African beads that we used. Danai's Zimbabwean roots include a tradition where beadwork holds a special significance, is a symbol of social status, and is extensively used in art and sacred ceremonies to appeal to the spirits. So, I thought, "protection" and "royalty." I beaded the entire tabard in the tradition of the Nigerian Yoruba diviners' belts, then added something special to identify each wearer. Towards the bottom of the tabard there is a crystal, a piece of jade, and a symbolic animal representing the tribe of each Dora. Each of these items are symbols of protection and personal sacrifice.

Top: Nakia (Lupita Nyong'o) in the Dora Milaje armor.
Bottom: Zuri (Forest Whitaker) presiding at the Warrior Falls.

Zuri

Forest Whitaker

Creating this look for Forest Whitaker was not simple. Modeled after the agbada garment worn by the Yoruba of southwestern Nigeria and the Republic of Benin, in West Africa, this costume consisted of four layers: the *awosoke*, the *awotele*, an accent layer, and the *sokoto*.

1. The top layer, the *awosoke*, consists of two hundred silk tubes joined together in a successive order that allows it to have an orderly yet free-flowing drape. I mixed in rope that was dyed to match, to give it dimension. It was crafted by a seamstress sewing together two-inch silk bias strips for four days. I worked with her at her table every day, laying out the order of the tubular shapes and mixing in the dyed rope to create the perfect combinations and lengths. It was made similarly to a poncho. We repeatedly put it on the form to examine it, which resulted in adding more loose silk strips down the back of the garment to allow it to have movement and to blow in the wind.

2. The next layer is the undercoat, called the *awotele*. It, too, is made of silk, and it is pressed in pleats, in the Issey Miyake style. Underneath the *awotele*, Zuri wears a lightweight black tunic with long sleeves and large cuffs. The black cuffs can be seen on the outside of the coat. I then used small silver metals made by the Tuareg of the Sahara. Using Tuareg pieces highlighted the intricate use of design in their silversmithing. Each piece of Tuareg jewelry has a special meaning. Combining the different elements made Zuri, the Wakandan shaman, represent more than one culture.

3. To create the accent layer, a long beaded front piece was added. The neck piece was crafted out of rope wrapped in leather and joined in the back by magnets.

4. The final layer is a pair of long red trousers, the *sokoto*.

Nakia and Okoye

Lupita Nyong'o and Danai Gurira

On the first day of filming, of course, I hadn't gotten a chance to get into my shooting rhythm yet. There was so much being created in multiple locations: in the Atlanta shop, in Los Angeles, in India, and in Nigeria—literally worldwide. I was up day and night. My focus had to be in all places at the same time, every day, every night. (I had plenty of assistance, I should add.) But this scene was a "cover set." Cover sets are lined up on the shooting schedule in the event of rain. You go to "cover." You don't learn that you are moving indoors to a new scene until the night before, so it is a scramble for everyone. On a project of this size, where almost everything is being built from scratch, it's very hard to turn on a dime and switch the order of scenes being shot. But it was going to rain, and I had better be ready.

With the information about the scene change coming in late, the night before, the head cutter, Kevin Mayes, was busy removing the collar from a pea green Lanvin dress I'd previously fit on Lupita. It was a nice dress. Very chic. I had decided to take the collar off to "open her up" more. Meanwhile, I was doing my customary circles around the workshop looking at every possible idea for Plan B, because I wasn't convinced I had the right dress. Like I said, it was good, but it wasn't *great*.

The costume department houses dresses and every type of rental garment, pieces bought by the shoppers, made-to-order pieces, and fabrics, and there's a constant influx of clothing moving to and fro. I sourced clothing from everywhere around the globe. And right at that moment, I was circling the floor. It was late. Everyone had left for the day, so it was just the two of us, me and Kevin. My feet hurt. Then, suddenly, I spotted it: a simple dress, a beautiful vibrant chartreuse. I took it over to Kevin and we threw in on a mannequin. This mannequin had been shaped to Lupita's exact measurements (a way of trying things on without having to have the actress present). The dress was made of a beautiful silk crepe, but it had a very stiff lining. I knew that the crepe would "give" more and hopefully give us just enough to mold and fit Lupita. But the lining was too tight. So, I said, "Remove the lining." Kevin began removing the lining from this beautiful dress.

The next morning, the day of the scene, around 5 a.m., sure enough, it's raining hard. And I'm concerned about Lupita, because it's always nerve-racking to gamble this close to shooting. What if nothing works? That's the stress, more than anything else. I go straight to her dressing room to fit the two dresses. I'm excited about the way the Lanvin turned out, but leaning on superstition, I don't give her that one first. I give her the chartreuse silk crepe to try first. And it fits incredibly on her! The color is outstanding! Then, for kicks and giggles, we try on the Lanvin dress. It's nice. But the color and the fit of the first dress, hands down, are so amazing on her, it's a no-brainer. Seconds later, there's a knock on the door, and I'm being summoned to Danai Gurira's trailer.

Left to right: Okoye (Danai Gurira) and Nakia (Lupita Nyong'o)

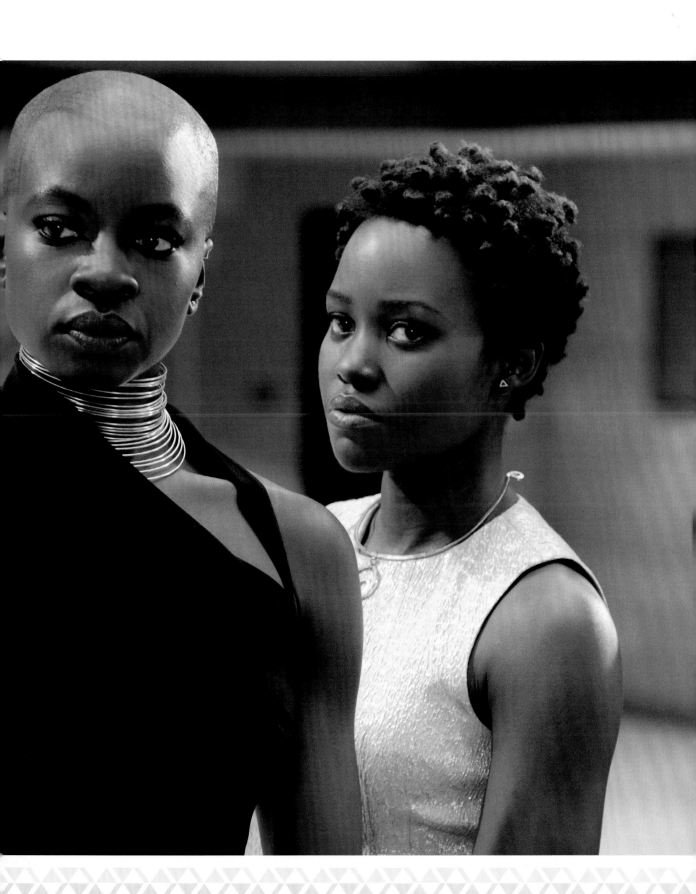

I looked at the dressmaker and I said, "Okay, let's remove the sleeves from here to there." Time was critical.

Danai had had her fitting for her black dress. It was complete. Lupita was the only one in flux regarding the perfect dresses for the end of the film. Florence Kasumba (playing Ayo) had also been fitted. All was good, in my mind. The look was ready to go! The requested concept was simple: Make Flo look the same as she did in that (amazing) scene in *Captain America: Civil War*. You know the one. She walks up to Black Widow and states, "Move, or you will be moved." (Loved that scene). And I did just that. Flo could rock a paper bag and make it look chic.

But what is Danai's request? I race from Lupita's trailer over to Danai's dressing room, in the rain, with my cutter/dressmaker in tow. When I arrive, Danai is surrounded by her on-set dresser and her personal dresser. They both have a look of concern on their faces. Danai looks at me and says, "I want to show

my arms!" The dress in question is a long, tight, silk jersey with long sleeves. And the whole cast for the scene were already on set. Without a second glance or any argument, I examined the dress closely and noticed that the design lines of the dress dramatically flowed around the shoulder. I looked at Tamara, the dressmaker, and I said, "Okay, let's remove the sleeves from here to there." Time was critical. We were gambling again. Off the dress went. Both sleeves came off in an instant. Tamara's hands were shaking the whole time as she sewed and cleaned up the edges. We had to work very fast. It was a miracle that Lupita's fitting went so well; that gave us time to work out Danai. And both dresses turned out beautifully. It was a purely instinctual move, and a big risk that paid off!

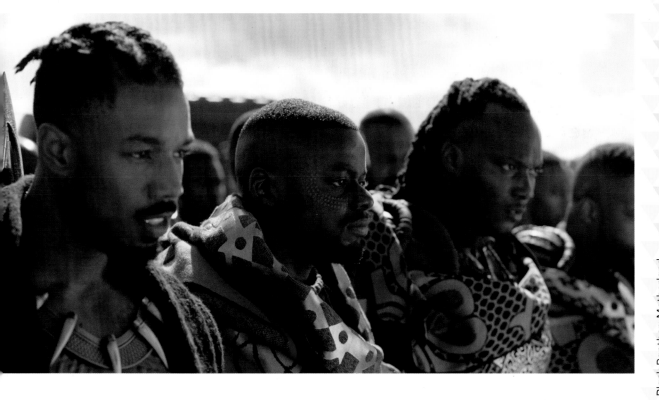

The Border Tribe

Lesotho blankets were requested by Ryan Coogler, who had observed them on a visit to the South African Basotho community. He wanted me to turn them into shields by printing vibranium on one side in the form of symbols. The vibranium would prevent the opposing forces from penetrating the shields. The blankets would be worn by the Border Tribe, who are Wakanda's first line of defense. We swiftly ordered close to one hundred blankets from a company in South Africa, the only company that manufactured them. Then we went through the process of silver leafing the symbols on one side.

The day came to camera test the costume. Camera tests usually happen very close to the first day of shooting. The actors are tested in hair, makeup, and costume. This gives the director and the studio a look at actors in costume and a final opportunity to give notes. The note that came to me regarding the blankets was not a good one. They liked the look and the idea, but they thought the blankets themselves were too thick—that they didn't drape well. And we should think about making them over. It was close to our Christmas break. We had no time to print them. The director was in love with the look. Christmas was canceled for a few of us, so we could figure this out over the break. During this time, Caroline Errington, my assistant costume designer, came up with an idea. She went out and came back with a men's electric shaver. She put a blanket on top of our large worktable and began to shave the pile off. Two hours later we had a thin, supple blanket. But this would have to be done to all one hundred blankets on both sides! Then Paul A. Simmons Jr., wardrobe supervisor, took another blanket, went outside with a torch, and burned away one of the fibers. That was much faster. But the blankets smelled awful, like burnt hair. We tried everything to get the smell out. Lemon juice, vodka spray, you name it—nothing worked. So, we ended up shaving them all. Merry Christmas!

Left to right: Erik Killmonger (Michael B. Jordan) and W'Kabi (Daniel Kaluuya)

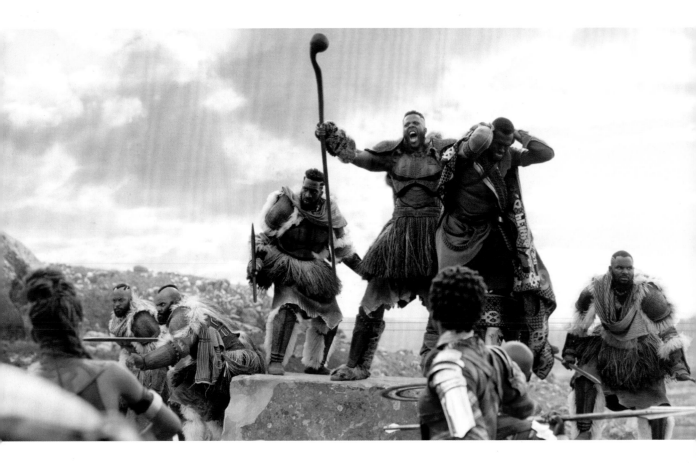

The Jabari

The Jabari Tribe was inspired by the Dogon tribe of Mali. After I shared the Dogon-inspired looks with Ryan Coogler, he decided we should create grass skirts for these warriors, similar to those worn by the Dogon during celebrations. I was game for it. Soon after, we began to craft the skirts. Then the actual stunt players and cast came in. They were massive guys, and I was panicked about seeing how they would look in these skirts. I had a few other items made, just in case. One of those items was a leather skirt. It was much longer than the grass skirt, and I put it underneath. This created a nice, layered effect and a longer silhouette. Thank goodness.

M'Baku (Winston Duke), **center,** with Shuri (Letitia Wright) and Nakia (Lupita Nyong'o) in the foreground

The Warrior Falls

The Warrior Falls scene was the only time all the tribes would come together in traditional garb.

When the fitting process was arranged, I had to put my stamp on this entire moment. I had done so much research, I felt like I knew who looked best for each tribe—the North Africans have a distinctly different physical appearance from the West Africans and so on. I didn't want to mess it up. So, in the fittings I wrapped every turban, draped every elder, adorned the proper beading on the proper tribe. I didn't want to leave it to chance. The trick was getting them undressed and out of my brilliant concoction, then hanging it up so it could be redone on camera day. I tried as best I could to teach the proper way of wrapping a turban. We stitched them afterwards, but some fell apart and everyone wanted my personal help on the big day. It was incredible getting everyone dressed for the Warrior Falls. I was proud to walk to the set and see all the magic unfold.

Below: Costume sketches for *Black Panther*
Next page: On-set photo from the filming of the Warrior Falls

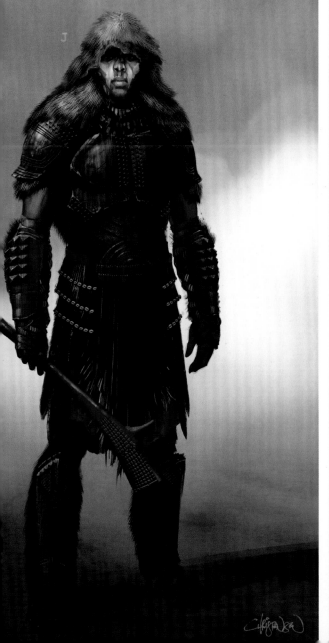

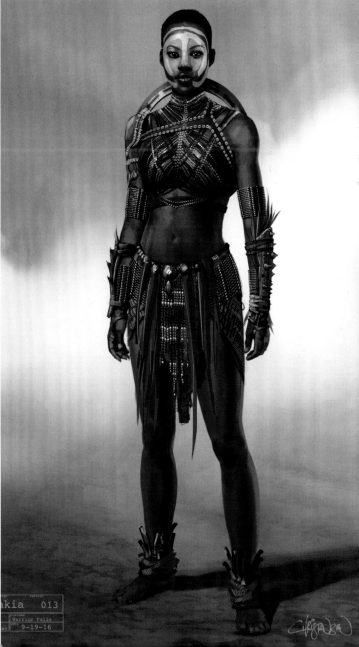

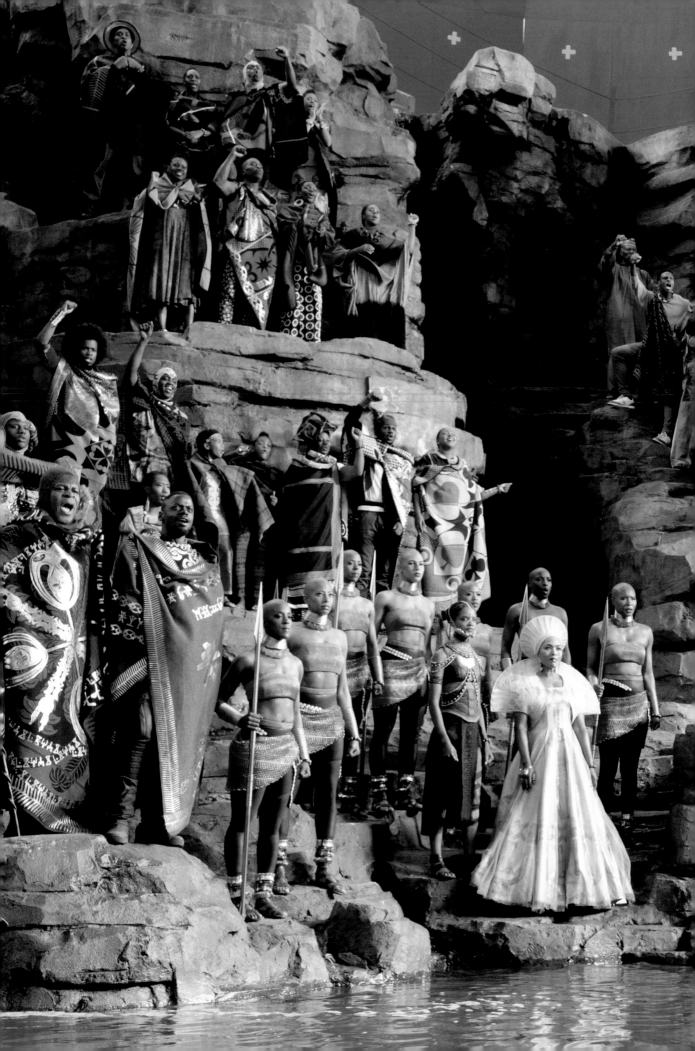

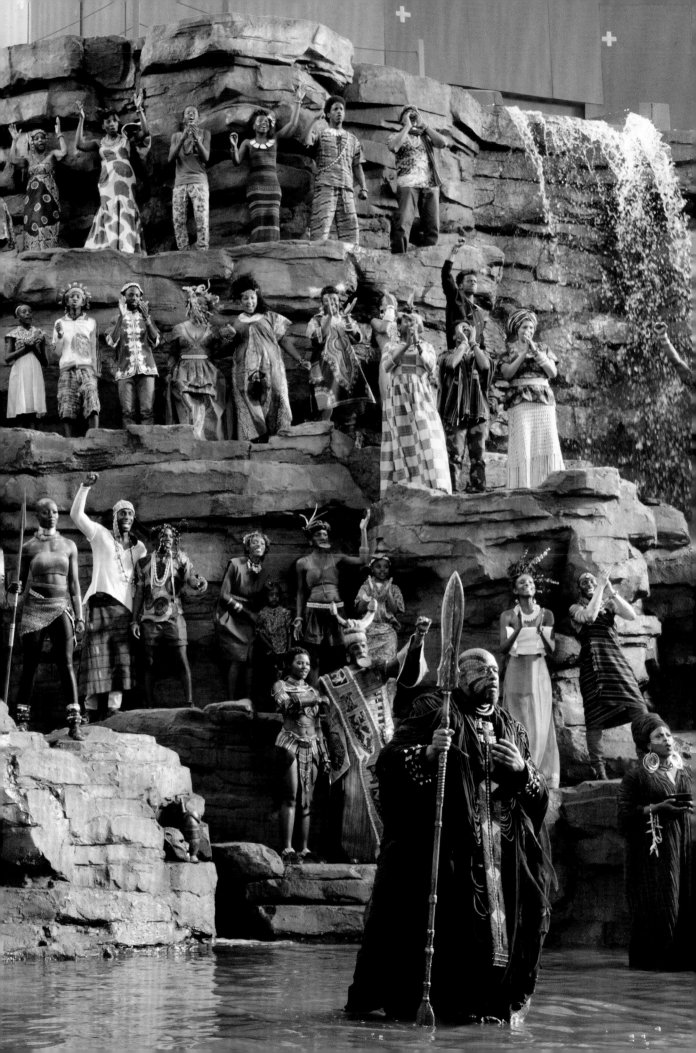

I was sitting outside the stage door getting some fresh air while we were shooting *Dolemite Is My Name*. There were only a couple of days left. I was wrapping up. Suddenly, the stage door opened and out of the door appeared Charisse Hewitt, Eddie Murphy's longtime assistant and producing partner. She stopped and looked at me with a smile, saying, "Ruth. You *are* doing *Coming 2 America* with us, right?" It's not every day that someone walks up to you and says something like that. Hollywood superstition says that you're only as good as your last job, and my last one wasn't even finished. The words *Coming 2 America* rolled out of Charisse's mouth like any ordinary day. But they hit me like a tornado. *Coming to America* was iconic back in the eighties. Sometimes I look at offers like they aren't real until I'm called by my agent or have signed on officially. If my agent doesn't call me about it, it's not real to me. But Charisse was dead serious, and this time, I knew it was going to happen.

The first *Coming to America* was so beloved. And still is to this day. It's very difficult to redo a film like that. I didn't want to be on a franchise that wasn't going to hold up to the first one. So I calmly and carefully remained positive, yet pensive. *Dolemite* was done, and I looked forward to a rest.

Lavelle (Jermaine Fowler) and
Mirembe (Nomzam Mbatha)

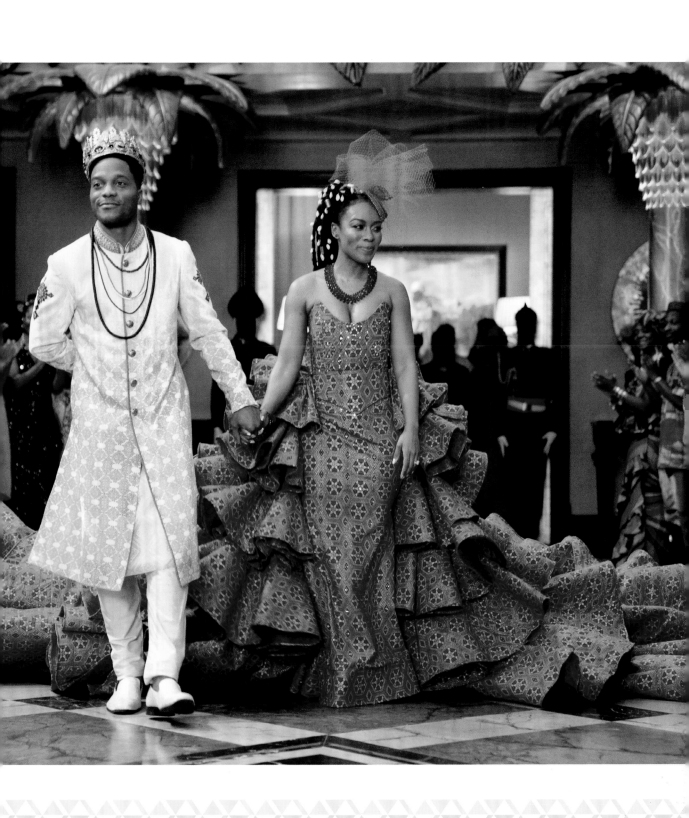

It had been a long, hot shoot through the summer. Lots of people wearing polyester and seventies-style bell bottoms. I needed some time to recharge.

I was back home for Christmas when I heard from Charisse again. "Hi Ruth. We are going to start negotiations for *Coming 2 America*. You're going to do it with us, right?" At the time, Spike Lee was after me to work on *Da 5 Bloods*, and Gina Prince-Bythewood was gearing up for her new film. Nothing was for sure. But I felt the pressure. Gina and I had begun prep and then her film was "pushed," our film term for delayed. Spike's script for *Da 5 Bloods* resonated with me. I thought I should hold tight and see how things evolved. It turned out that *Coming 2 America* was the one for me. The others just went away.

I cracked open the script and got into it right away. The script felt like a continuation of the first movie and not a remake. It was funny, and it was a love story, a coming-of-age story, a movie about how women can lead in Zamunda. I then returned to the first *Coming to America*. It was directed by John Landis and designed by his wife Deborah Nadoolman. I remembered the bigness of everything. The clothes and the entire production felt like a big Hollywood film from yesteryear. But in fact it was thirty years ago. Since then, we've learned so much more about Africa. And the pressure was on me to deliver again.

Zamunda, the fictitious African country in *Coming to America*, amplified African royalty. Wakanda, another fictitious African country, in *Black Panther*, was very different. They were two fictitious countries with distinct aesthetics. And I knew this from the start, but the overwhelming love for Zamunda made it a comparison point during the making of *Black Panther*. I'd exclaim to everyone on the *Black Panther* team, "People!

This is not *Coming to America*!" It became a serious personal mission for me to make Wakanda look nothing like Zamunda. Not that there was anything wrong with *Coming to America*; it was just being done totally differently. We were creating Wakanda as a place that had never been colonized, based on real African tribes, ancient techniques, and old-world idealizations. We created *Black Panther* in 2016. Now, it was 2019, I was making *Coming 2 America*, the sequel, and I found myself sitting in the middle of my workroom with so many who looked at me with *Black Panther* stars in their eyes, hopeful that they would see some of the same majesty. And I'd shout out, "People! This is not *Black Panther*!" Man, that was a challenge!

Eddie Murphy's first fitting was a Western costume. I was a little nervous. I knew I needed to create a Zamundan king and not a comedy showman like we'd just done with *Dolemite Is My Name*. This was the opposite. I needed to learn his character and compose it on the same body all over again. I wanted Eddie to begin to feel the character as well. I bought a bunch of Yoruba crowns on Etsy, and I decorated the fitting room with them to give the atmosphere an African feel. The shoppers bought a tremendous number of shoes for his character, mainly because I had tortured him so badly in the last film, with all the seventies platform shoes, I felt an obligation to the comfort of his feet. We lined the walls with racks and racks of costume looks and lined the floor with shoes. Eddie came in, in his customary black hoodie and dark shades. He was in a great mood. It felt like he was willing to give us the time we needed to get the job done right. Everything went well for this first fitting. We styled him with many layers: silk shirts, brocade vests, and velvet jackets. I came up with the "royal embroidery" of masks and paisleys. It was all about fun, and everything was approached lightheartedly, not

seriously. But there were many more fittings to come. I knew that we'd have good fittings and some not so good in our future. That's just how it goes in the costumes department.

Challenge number one: Make sure we gravitate to the things that made *Coming to America* great the first time. Ankara fabric was one. Ankara was originally manufactured by the Dutch for the Indonesian textile market. However, the prints gained significantly more interest in West African countries because of the tribal-like patterns in big, beautiful shapes.

Challenge number two: The women's clothing in the first film was unforgettable. The large

bulbous shapes and headpieces left an indelible impression on me as a young hopeful. The menswear was formal and regal. I noted to myself that we would follow that model, so that the film tapped into that nostalgia.

Then came my many thoughts about the upgrade. I knew I needed to keep Eddie Murphy's custom wardrobe made locally so I could monitor it and get the fittings done without any drama. Arsenio Hall's as well. The two of them needed to lead the way into the Zamundan look. The same would go for Shari Headley as the girl from Queens who is now the queen of Zamunda. I wanted to keep their looks close to me so that they had the appearance of royalty, and royalty in this case meant using lots

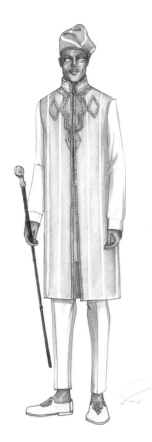
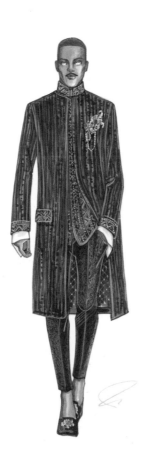
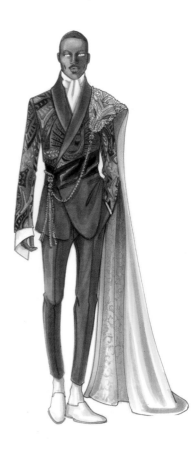

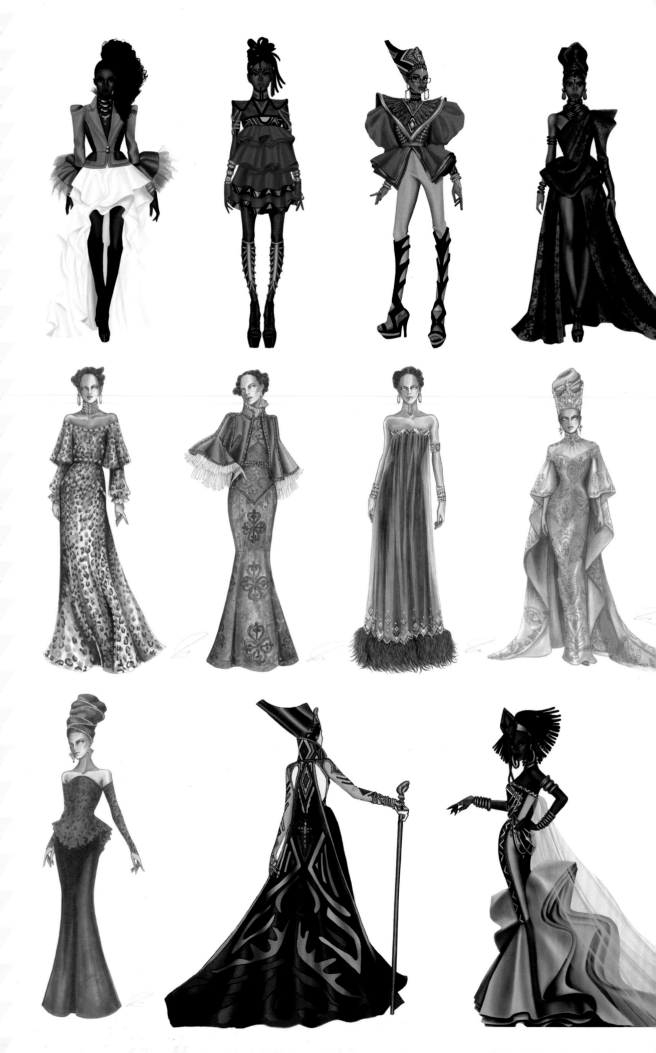

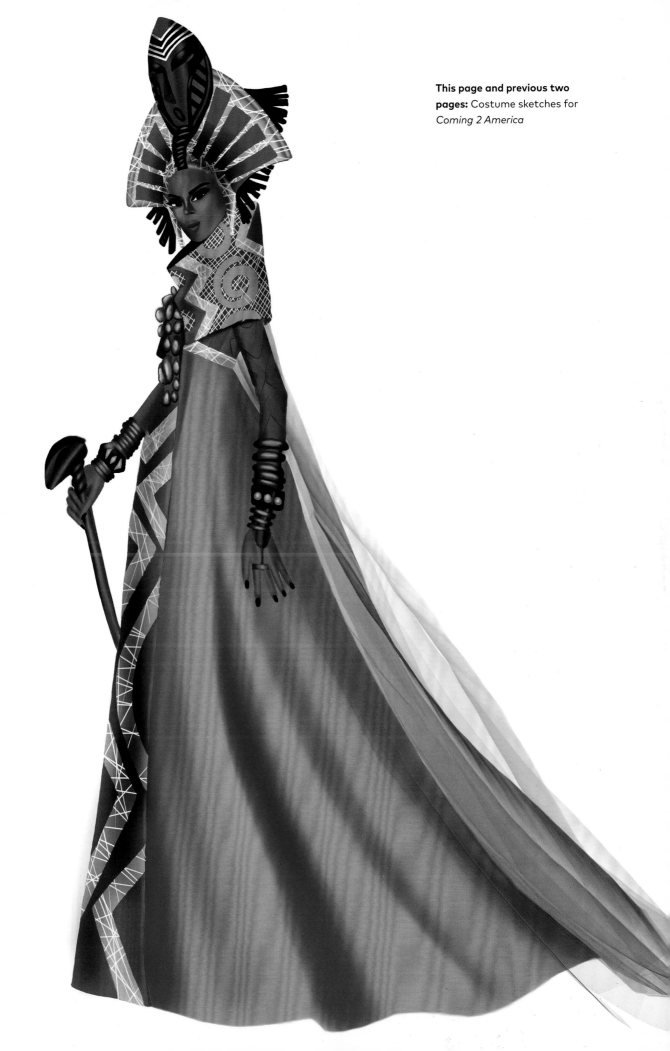

This page and previous two pages: Costume sketches for *Coming 2 America*

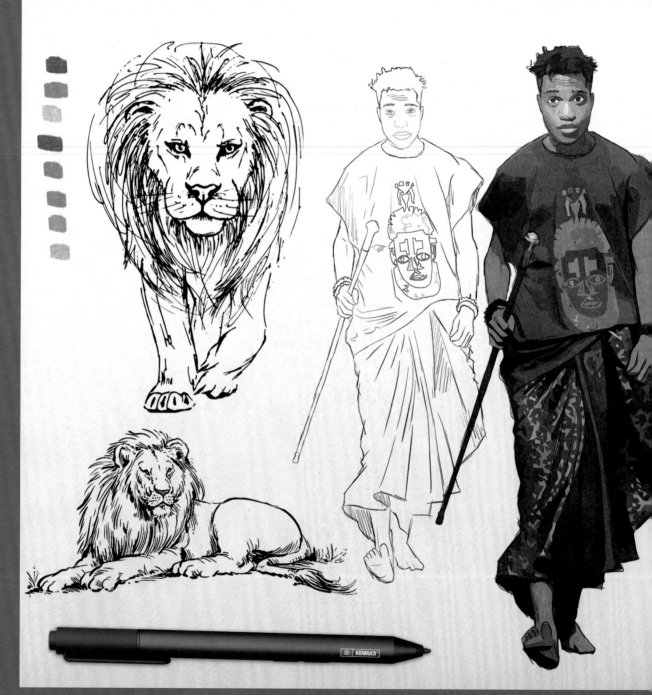

I chose more than three dozen international designers to collaborate with me on *Coming 2 America.*

of embellishments like embroidery and crystals and gold.

I also wanted to be globally inclusive with the sequel. As costume designers are now much more aware of global brands, I invited many African and African American designers who had the proper aesthetic I was looking for. My team researched and presented many options for me to review, and I chose more than three dozen international designers to collaborate with me on *Coming 2 America.*

I found JJ Valaya of the House of Valaya online. I had researched many East Indian designers and wanted to find someone who had an eye and also would collaborate and produce pieces that we could build into the Zamundan storyline. I chose garments from JJ's line and sent him our women's illustrations, along with an accompanying graphic of masks and tribal designs that should be integrated into the design. We had many beautiful pieces for all of the royal family.

Palesa Mokubung of South Africa is a designer I became familiar with when I visited her boutique on my trip to South Africa in 2019. I saw in her collection a dress that I thought would be perfect for the middle daughter to spar in. She submitted a few designs with a big cloverleaf pattern on

them. But when I received the dress, I discovered that the large cloverleaf pattern was actually Palesa's face laid out in four directions. It would be impossible to put it on camera. Even the dress that I loved at her boutique was printed with her face; however, it was very small and thus wouldn't distract, so we dressed Omma in it.

Mimi Plange I met on a panel discussion at the Skirball Cultural Center in Los Angeles. After listening to her design ideas, I thought we had something in common. She was also interested in redirecting aspects of African culture, like scarification, and producing beautiful leather pieces. I reviewed her line sheets and selected a beautiful leather piece for KiKi Layne, as Meeka.

Laduma Ngxokolo of Maxhosa Africa, based in South Africa, had the largest presence in the Zamundan story. His vibrant prints made him an obvious choice when creating the look for the staff. He also owns his own plant and could produce the looks from his own source.

Claude Kameni's Lavie by CK was known for dressing the likes of Tracee Ellis Ross and Viola Davis. We went to her for the iconic wedding dress in the film. It had to follow suit with the dress from the first film, which had an enormous train.

Sergio Hudson, a designer who went on to create the ensemble Michelle Obama wore at the inauguration of President Biden, would create two pieces for Leslie Jones for a scene at the end of the movie.

Other international designers included Melody Ehsani, Ikiré Jones, Laurel DeWitt, Khiry, Afia

Costume sketch for Lavelle Junson

Sakyi, Andrea Iyamah, Sewit Sium, Kaya Designer
Lounge, Lagos, International House of Style,
Haute Baso, Douriean Fletcher, Woody Wilson,
Ugo Mozie, Panche, Jahnkoy, TruFacebyGrace,
and others.

The trick was to get these designers to follow the
costume-design plan and deliver on time. We ran
into issues with customs, but all in all everyone
would deliver.

Every night when I went home to my temporary
apartment in Atlanta, where we were filming, I
would watch *The Crown*. I was new to the series
and needed to start from the beginning. It was
fascinating and very inspiring to watch a show
about royalty as I created the looks for Zamunda. I
fashioned some of my guard uniforms with inspi-
ration from the looks of *The Crown*. I also created
a family tapestry design that was embroidered on
King Akeem's royal garments. I knew that the idea
of having a taxidermied lion perched on the shoul-
der of the king would not be acceptable for the
daughters, so I 3-D printed a large gold lion head
instead and embellished it with gemstones.

During Arsenio Hall's fitting as Semmi, one of
the coats he was to wear looked too heavy for
Africa. However, I had chosen a beautiful lining.
So beautiful, in fact, that we turned the coat inside
out and he wore the lining as the outer fabric with
the velvet inside. That act informed the rest of his
clothing. We would go on to use luxury silks and
brocades to create all of the costumes in his story.

The large party scenes in the movie required the
most advance planning. From day one of prep, I
knew that if I was going to get that regal look in
the big ballroom scenes, like in the first film, I had
to act fast. So I began to work with fashion and
costume illustrators Paul Keng, Ashandal Edwards,
and Felipe Sanchez on several line drawings of the

Lisa (Shari Headley) and Prince Akeem
(Eddie Murphy)

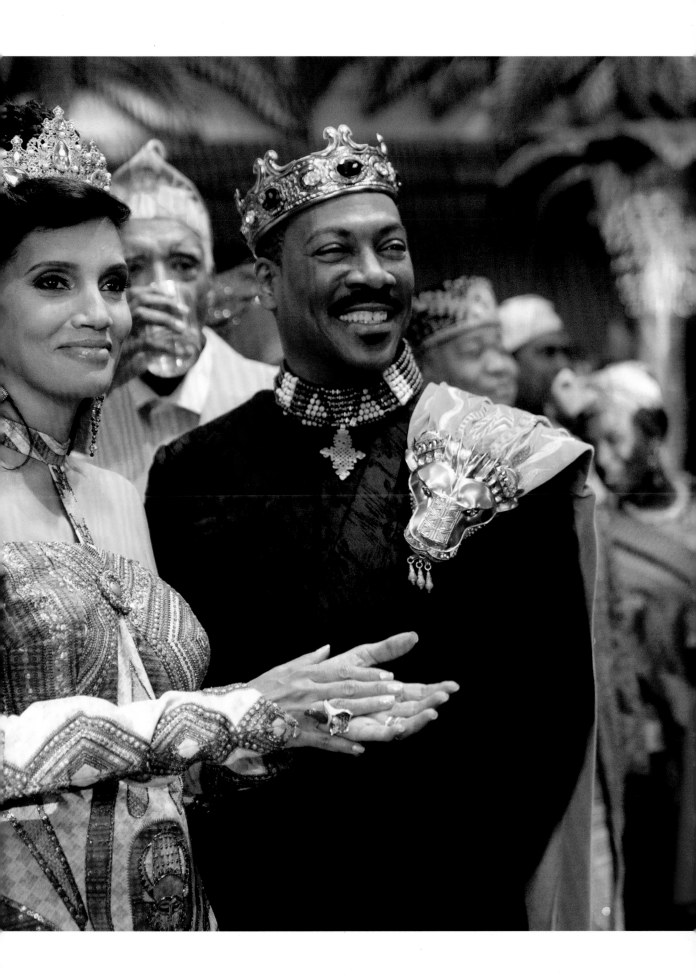

We crafted headpieces, painted dresses, silk-screened, combed raffia, bedazzled Randy Watson, and dressed En Vogue, Salt-N-Pepa, and Gladys Knight.

women in the court. Lots of shapes were created. I then paired them with all kinds of African and non-African fabrics. Next, my assistant went out and gathered contemporary inspirations from showrooms and rental houses. We swatched those with colorful fabrics as well. Then we began the process of creating a large stock of dresses over the entire period of prepping the film so we would have enough to fill the room.

The men in the ballroom scenes were also important to the opulent look. I wanted to see the nostalgia, so we created sashes and neck-pieces adorned with ribbons. The suits were sourced in India by Kaya Designer Lounge and featured asymmetrical hems and front clo-sures. This scene also included a nineties *Coming to America* signature envelope hat with a brooch. There were new hats that I fashioned from "Zulu Dandy" hairstyles. I called them "hair hats," and I rotated them among the palace staff.

We created a very efficient workroom. When the time came for me to design the dancers, I was well out of steam, and I wondered if I had the stamina to make them as special as I felt the rest of the film was. Especially because I wanted to put more "Africa" in these dancers. My crew stepped up and kept pace with the momentum that was flowing. It was wonderful to bring each dancer into the fitting room, one by one, and create a costume for them. We cut strips of Ankara fabric and mixed it with raffia. We made headdresses and arm and leg bands that flared and moved with the dance moves. I was proud of each one.

Leslie Jones (Mary Junson) arrived with a small entourage. They were nice and helpful. We crafted

her look, and she was amazing to dress. Tracy Morgan (Uncle Reem) came in with a boom box and talked about his next film and all kinds of other topics. When he left, I don't think he could recall that during his excitement he had had a fit-ting. We sometimes know how to get you dressed without you losing your train of thought! Garcelle Beauvais (Rose Bearer Priestess) had an enormous red-and-gold dress that needed its own corner of the room to live in. I'd ordered the dress online and figured somehow, some way it would make it into the film. In Teyana Taylor's (Bopoto) fittings, she conducted business on her cell phone the entire time and left everything up to me. It's very nice to know that you have been granted that level of trust. Her outfits were stunning. But how can you mess her up?

The barbershop men were what I remembered as the most magical from the first film. I was excited to create their costumes just like the costumes in the original. Same for the preacher and Randy Watson. Those characters were the cornerstones of the film. I was honored to dress them for the sequel. They represented so much of the legacy of the three comedians who portrayed them.

By the end of the process, we had created more than eight hundred garments. From Eddie Murphy and the royal family to the uniforms for the burger joint, McDowell's. More than three dozen African and African American designers were involved. We crafted headpieces, painted dresses, silk-screened, combed raffia, bedazzled Randy Watson, and dressed En Vogue, Salt-N-Pepa, and Gladys Knight. This was the film of the COVID-19 pandemic. And not one dull moment in front of or behind the camera!

Costume sketches for the employees of McDowell's

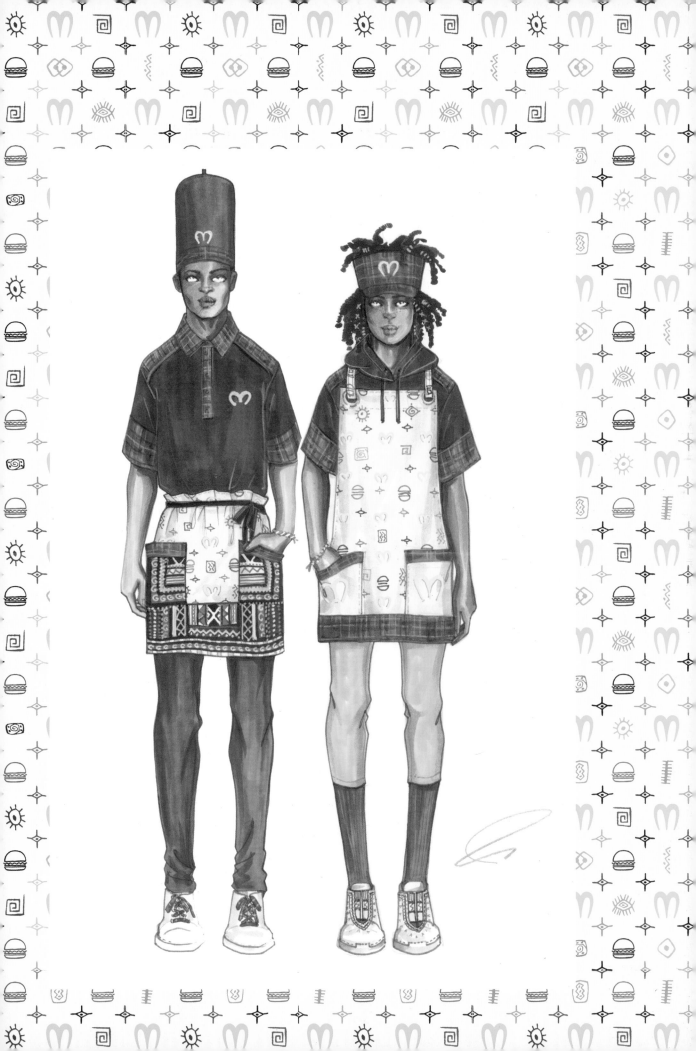

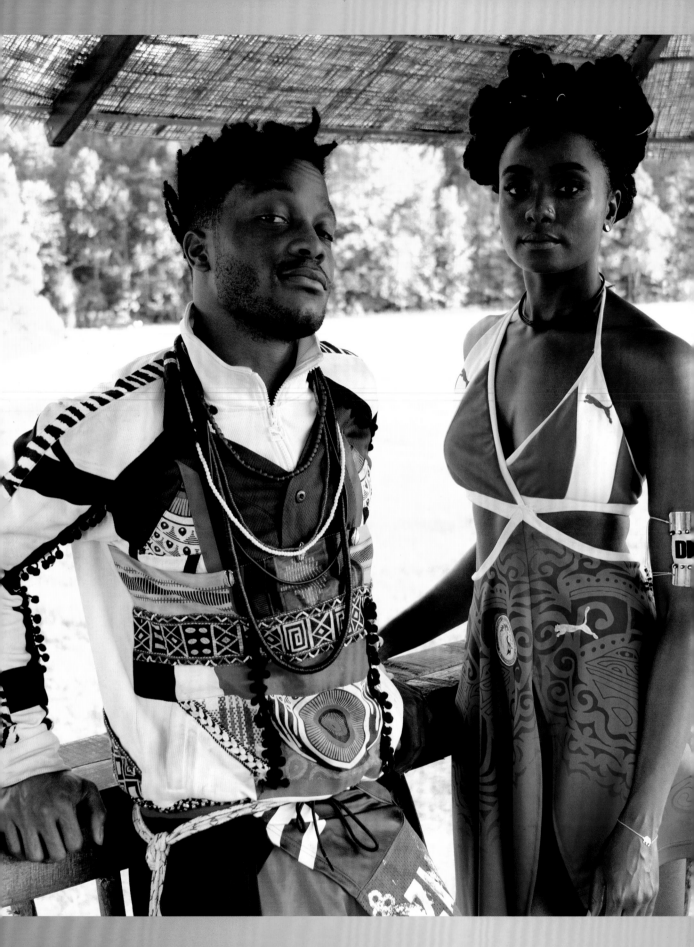

Lavelle Junson (Jermaine Fowler) and
Meeka (KiKi Layne)

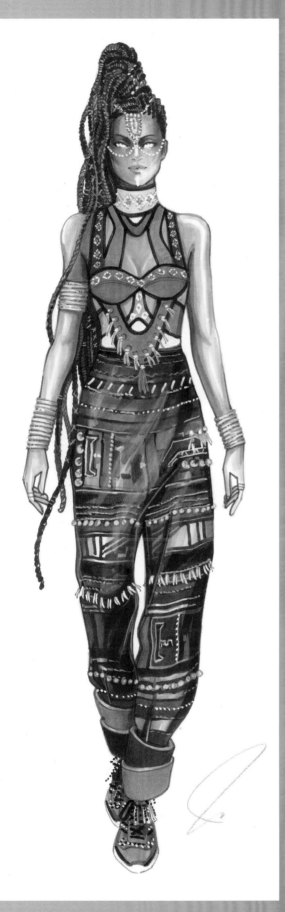
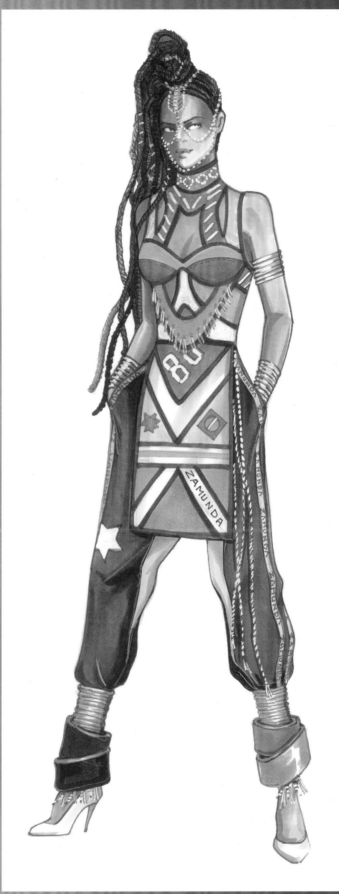

Above: Costume sketches for Meeka
Next page: The Zamundan royal family
and attendants

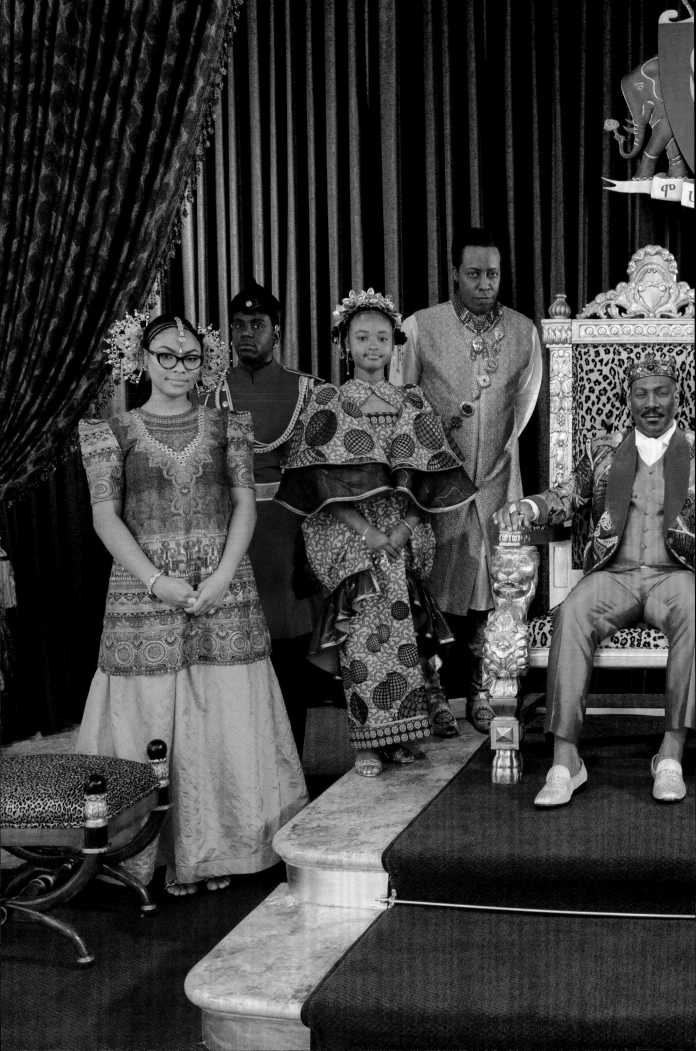

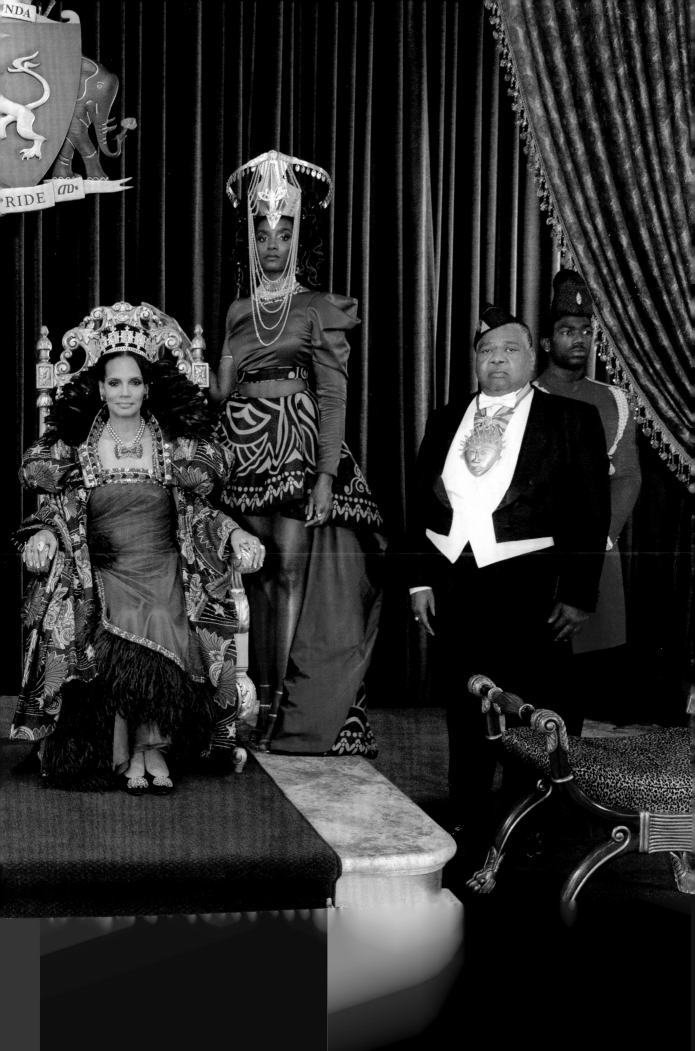

In the summer of 2020, in the middle of the global COVID-19 pandemic, I began the costume-design journey for *Black Panther: Wakanda Forever*. I was enthusiastic and elated about bringing the new story to life. The pandemic made it very difficult, because people were very cautious and the world had shut down, but I found the support I needed in big and small places from Los Angeles to Atlanta, Africa to Siberia, India to New Zealand. It was fascinating to work with such great, talented people and companies around the globe. And before long, our costume department video calls were spirited and creative.

Then, the most unexpected happened: I received the news that Chadwick Boseman had passed away. Stunned and heartbroken, I sat quietly for hours, wondering why I was so far removed from any knowledge that he was suffering. I thought of him and how difficult it must have been for him to endure, yet how dignified and brave he was to keep very private the one thing that would have rallied all of us to his side. I reflected on our fitting-room sessions when he tried on the Black Panther suit for the first time, and how magical it was. When my name was announced as the winner for the Oscar for Best Costume Design, Chadwick was the first to leap out of his seat and applaud. It was an honor to collaborate with him and make history together, bringing to life King T'Challa and the Black Panther.

Shuri (Letitia Wright) carries the helmet of her late brother, King T'Challa.

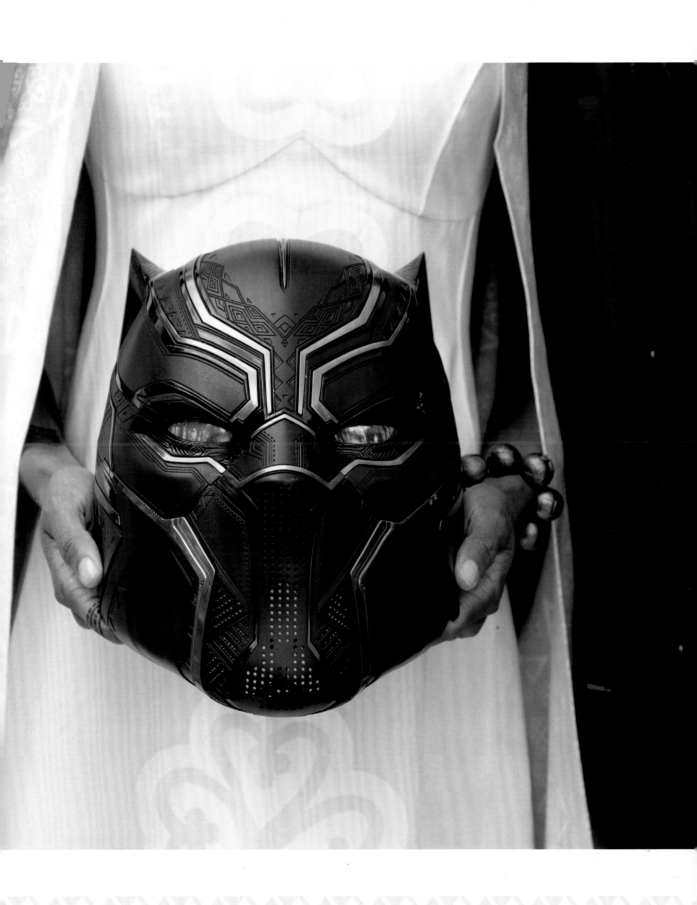

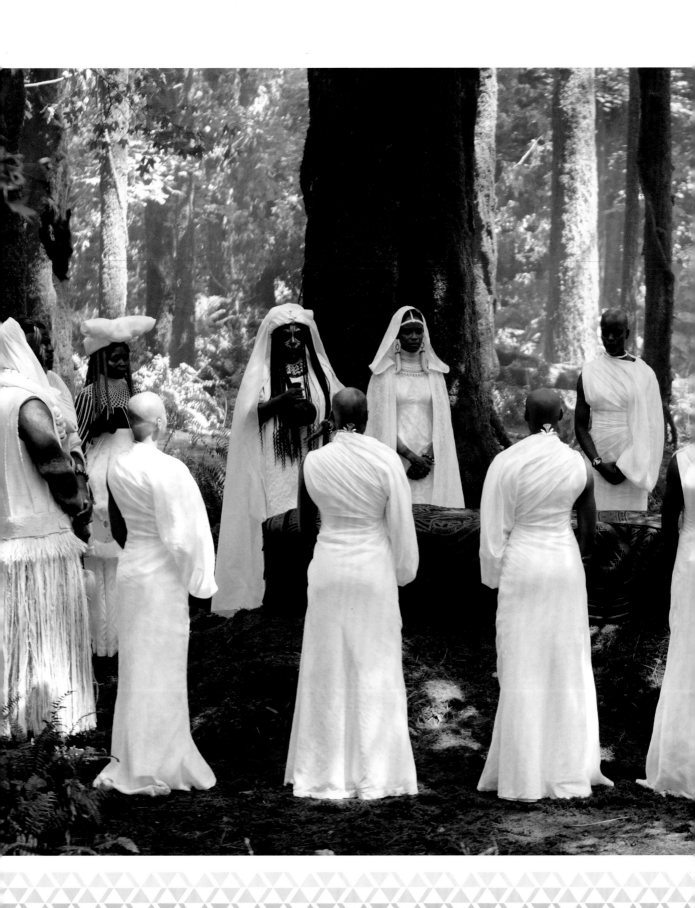

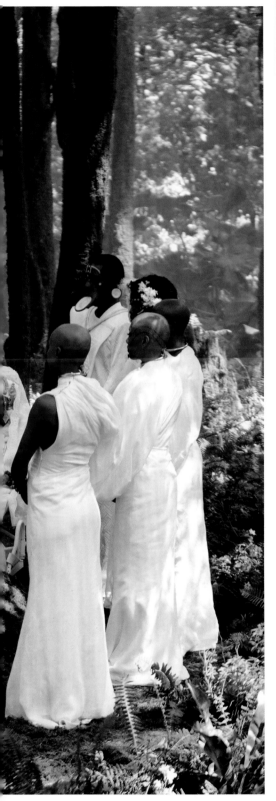

A Wakandan funeral

> **Chadwick had touched us all in a special and very individual way. He was dearly missed in creating the work of art that is *Black Panther: Wakanda Forever*.**

Production was put on hold until it was determined that we were to keep moving forward creatively. Director Ryan Coogler and writer Joe Robert Cole crafted a new script, a story about grief, loss, and bravery. As we quietly returned to prepping the film, the emotions ran very deep. The scenes that celebrated T'Challa's life also reflected Chadwick's true spirit, and we responded to the new script purposefully. We will never really know how much pain Chadwick was in, the way he poured himself into the first film while fighting his battle silently, so all departments poured themselves artistically into the second film as a tribute to him. Chadwick had touched us all in a special and very individual way. He was dearly missed in creating the work of art that is *Black Panther: Wakanda Forever*.

The task of making any movie is daunting, especially a Marvel film, and even more so when the lead actor suddenly passes away. So much planning and coordination goes into a project like this—a sequel to a movie that made history. There's an intense collaboration with highly talented, world-renowned filmmakers and artists, and you really need to find your creative flow. Ryan Coogler, producer Nate Moore, production designer Hannah Beachler, and scores of others in Marvel's arsenal of genius converged in meeting after meeting, week after week, sharing story and visual ideas. During each meeting, I presented illustrations and talked through ideas. If I stopped and thought about who I was presenting my ideas to—one of the biggest studios in Hollywood—then I'd miss how much they all believed in my work. I'd miss how Ryan Coogler can lead fearlessly and make everyone feel welcome, like a family. It was still a tough room. But

> ▶ **We wanted to honor Maya**
> **culture and highlight what is**
> **traditional while having the**
> **Talokanil transcend into a**
> **futuristic Indigenous look.**

if I had learned anything from my first *Black Panther* experience, it was that I could trust my point of view and my way of telling a story through costume design.

From August to December of 2020, I presented costume concepts to Ryan via illustrations and mood boards and then reworked those ideas into 3-D renderings. This was a highly curated process that included not only many concept artists, but also costume assistants combing through sources as they researched African culture, contemporary fashion, and new innovative technologies. We were rediscovering Wakanda and introducing the new, underwater world of Talokan and the Talokanil, a setting and a people also rich in vibranium but rooted in post-classic Mesoamerican Maya culture. To incorporate the beauty of that civilization into the costumes, we referenced the Maya Vase Database, a unique and extensive archive of Maya knowledge, resources, history, and art. We examined the Maya codices, paintings, artifacts, and hieroglyphics; the Jaina figurines; and pottery by Maya artisans who detailed incredible meaning and stories in their designs. We teamed up with experts in Maya archaeology and culture who could help us interpret the language and narratives and understand the details.

The first film highlights Afrofuturism, and the costumes are a tribute to Africa, reimagined without the limitations of colonization. For that film, we merged traditional and modern aesthetics to create form and function that manifests as futuristic. This is the same approach we used for the second film when introducing the world

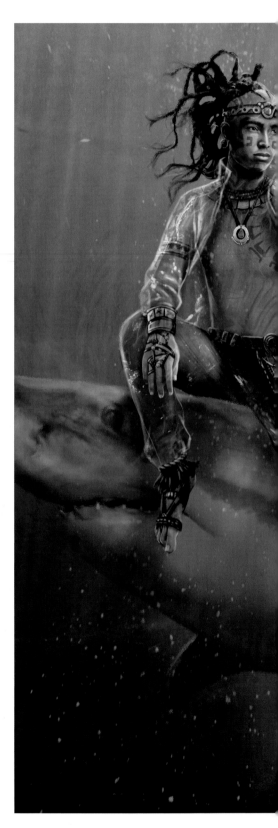

Costume sketches for the Talokanil

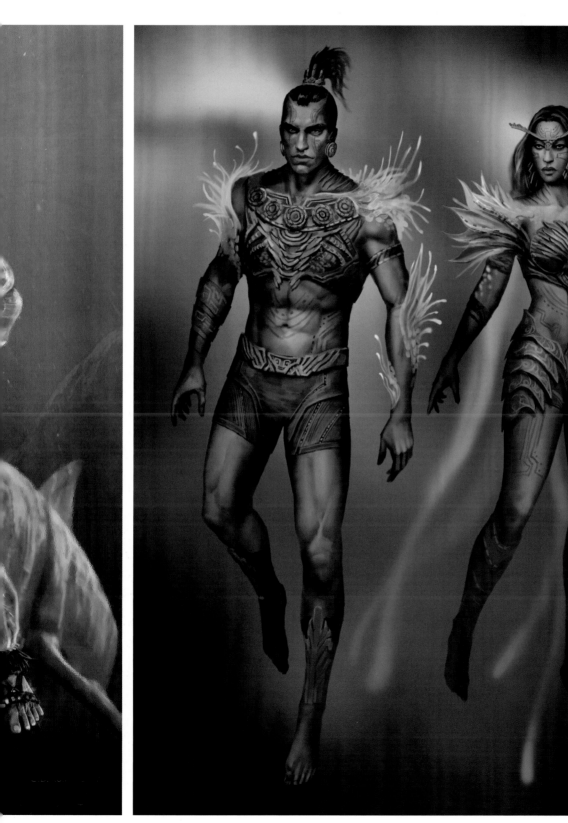
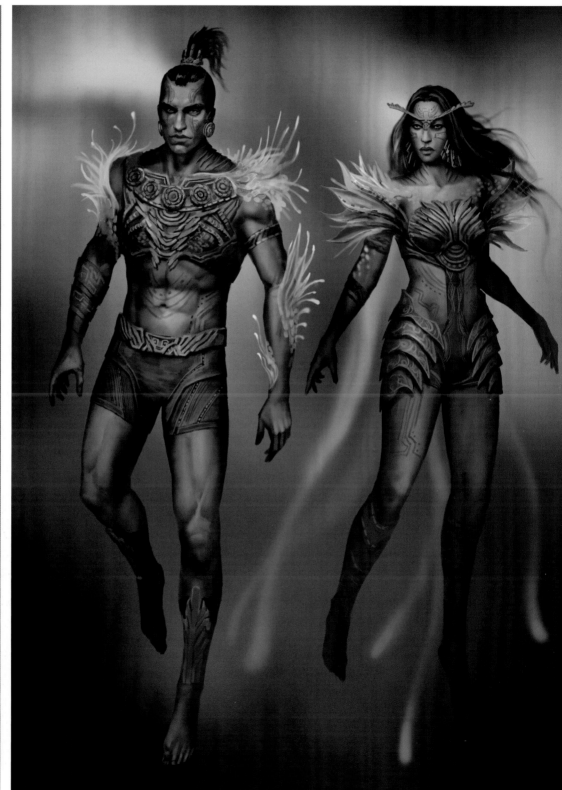

of Talokan. We wanted to honor Maya culture and highlight what is traditional while having the Talokanil transcend into a futuristic Indigenous look that complements their underwater world, adapts to land, and shows how well preserved their culture has been over generations.

In the first months of 2021, we began implementing our approved ideas. The lead time to fabricate most of the main pieces was reaching a critical stage. Six months is a long prep time in the costume design world, but it was the absolute minimum necessary to create our complicated costume builds. Together with many assistants and department supervisors, I scrambled to get illustrations into our vendors' hands, so that they could get their bids in. We returned to many of our tried-and-true vendors, commissioning them to build the new Panther suit, and we brought in new companies for a host of new costume builds.

We set up our costume-design office at Tyler Perry Studios, a brand-new studio lot in Atlanta, where each stage is dedicated to an iconic Black filmmaker or actor. Ironically, I moved into stage 10, the Spike Lee Stage. We had all three floors filled with costumes from the first *Black Panther* film and the sound stage filled with crafts: specialty 3-D design and printing; clay sculpting; dyeing and aging; tailoring (with a massive stock of fabrics); and African clothing, beads, leathers, and furs. Each day, as I walked through the department from floor to floor, room to room, I reminded myself that to have this number of staff, and this amount of space and materials to work with, was a blessing that I should take full advantage of in order to take the art of costume design to new heights.

The project was extraordinary and exhilarating—one of the most challenging costume-design undertakings of my career. There were several superhero costumes introduced in this film and into the Marvel Cinematic Universe: brand-new looks for Namor, Namora, and Attuma; the

Midnight Angels, whose look was taken straight from the comics, with African-inspired masks and Wakandan designs; and Ironheart, a.k.a. Riri Williams, played by the emerging Dominique Thorne—her suit was done entirely off-site, while her everyday look was very American. Since Shuri is a tech genius, she is continually upgrading Wakanda's capabilities. To reflect that, we elevated the looks for each Wakandan character. We upgraded armor for both M'Baku and the Dora Milaje with design elements featuring incredible sheen. Nakia wears a new submersible suit and helmet, both of which we made in-house, that have a bioluminescent design.

This whole story required a level of culture and fantasy that we were able to find in the world of art and fashion by collaborating with many creative artists. Their beautiful sculptural pieces were forms of wearable art that looked like they came right from the sea. Select haute-couture artists fused technology and fashion for this film in a way that supported the story and brought Afrofuturist concepts to the foreground.

The specialty-costume-making process was fascinating. In-house, we were able to sculpt armor and headpieces out of clay and then make molds out of them for duplicates. This process was helmed by a very talented group of artisans. Every day we created each part of this new story through building, aging, and dyeing, and all the departments collaborated with one another.

The funeral procession scene, our tribute to Chadwick, had to be all white. We consulted with historians of West African traditional funeral garb, and they told us that it was often all white or all red. For T'Challa, Ryan decided on an all-white funeral—not off-white, but pure white. Normally, this isn't good on camera. White refracts so much light that it tends to glow. But in this case, the scene was designed in this manner, and we worked with it.

Aneka (Michaela Coel) wearing the new armor of the Midnight Angels

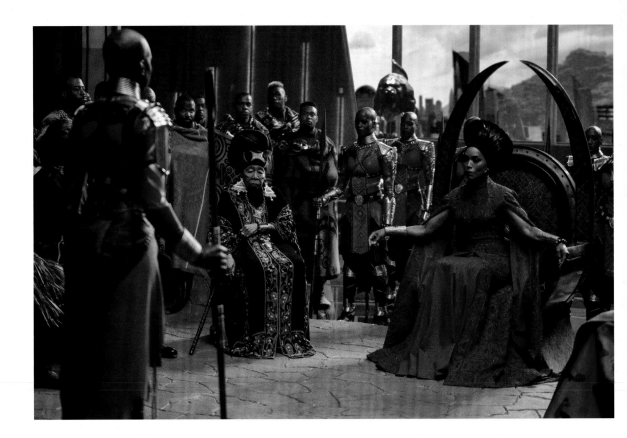

The cast came in for fittings, and we illustrated and collaborated on each individual look. For the background actors, I began looking at all of the Wakandan tribes and thought about how I could translate their details, especially the heavily layered African tapestries, into the pure-white idea. We began to screen print African graphics on fabric. Then we painted beads and beaded pieces white. We constructed headpieces inspired by the Himba, the Maasai, and the Turkana. For the dancers' skirts, I had rope stitched together and then brushed out to make it look like raffia. But one of the most challenging costumes was M'Baku's all-white funeral look. He was to wear his ceremonial Jabari grass skirt to the funeral, and I couldn't find the aesthetic for it for a long time. I put the skirt on his dress form and let it sit there for days. I put fabric on the form to cover the torso and still didn't have a vision for it. Then, one day I lowered the skirt to the hip. That's when I could see my way into the design.

The ruler of Wakanda was now the incomparable Queen Ramonda, played by my friend and longtime collaborator, the legendary Angela Bassett. I was not only re-creating the image of the queen from *Black Panther* but also elevating her to ruler. The first direction was to give her a new crown, one of authority and power. I went back to Julia Koerner, the 3-D artist I'd collaborated with

on the first film. Julia and I added a front piece that was then detailed out on the computer. We received the beautiful crowns, and our specialty-paint costumer chromed and painted them to match the outfits. Ramonda's dresses were designed to inhabit the same throne upon which King T'Challa had once sat. I wanted her to look at home sitting there. Ryan examined the sketches and made selections for each scene. A red dress was chosen for the scene with the greatest intensity, when she expels Okoye from the Dora Milaje. I included African patterns and added a mud-cloth design to the inner skirt. Ramonda's "drowning dress," on the other hand, with its purple-to-white ombré pattern, was inspired by the beautiful costumes worn in water ballet.

I was very excited to create a submersible suit for Nakia, played by the breathtaking Lupita Nyong'o. I wanted to evoke a look of bioluminescence, inspired by South African body painting and technology. The suit would involve raised printing and Eurojersey, similar to the Panther suit, with hard plastic shoulder and knee pieces. This costume also required a helmet. I needed to quickly blend a number of processes together to

Above: Queen Ramonda (Angela Bassett) relieves Okoye (Danai Gurira) of her duties
Opposite: Costume sketch for Queen Ramonda

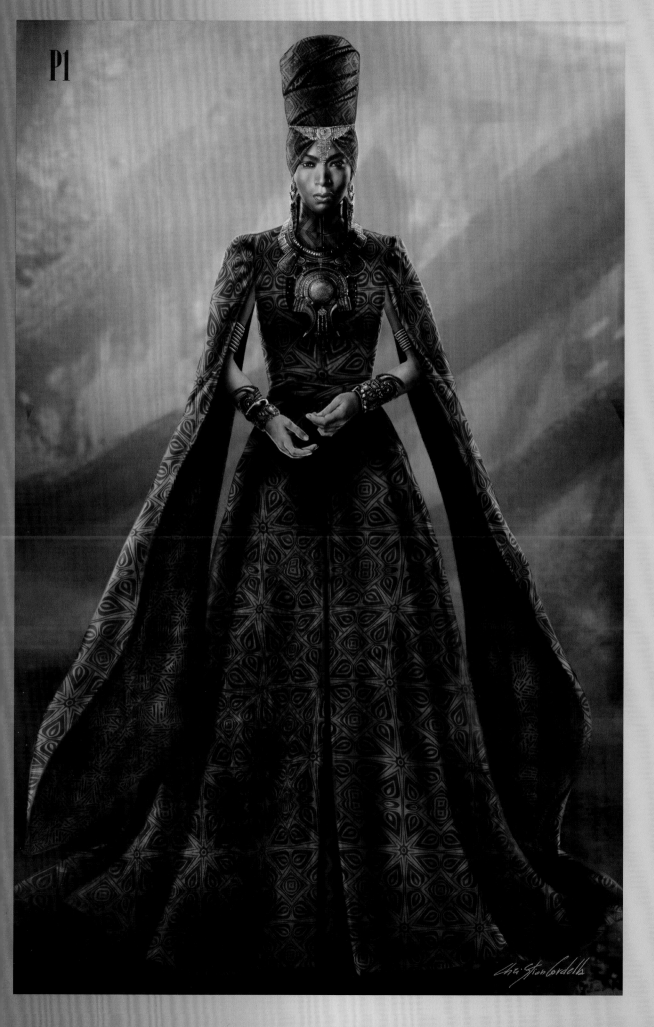

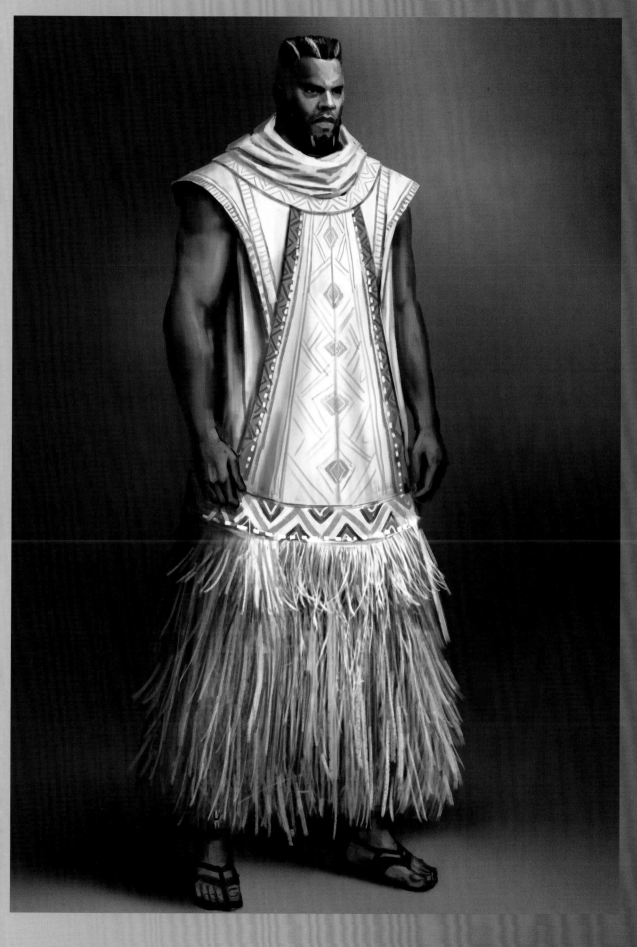

Above: Costume sketch for M'Baku

Opposite, top to bottom: M'Baku (Winston Duke), left, offers advice to
Shuri (Letitia Wright); Ruth dresses actors for a Wakandan royal funeral.

make what seemed to be impossible. The base of the suit consists of many pieces that were first created in white. The pieces were fitted together on a form that is an exact replica of Lupita's shape. This structure was then given to an artist who painted the design onto the white suit. Once that stage was approved and completed, we took it apart and scanned it into a computer, where the lines were trued up and the small design lines within each shape were added. We carefully examined each pattern piece for accuracy. Then the patterns were raise-printed on brown Eurojersey in the colors desired. The final printed pieces were sewn together and fitted back onto the form. The hard pieces were 3-D printed, matched to the design, and adhered to the suit. It took several weeks to create this costume. The sides were designed to hold Nakia's ring blades, and the colors were chosen to camouflage and disguise her—as a defense—as she enters the underwater world. When I saw the final cut of the film, and Lupita appeared in the suit and turned on her helmet light, my heart lit up as well.

The new Dora Milaje armor was beautifully designed. A major scene in the story would require filming them in battle while submerged in water, so it was necessary to make a mold of the original costume's leather harness and cast it with silicone. But the molded rubber harnesses were very uncomfortable to wear. The specialty team was constantly adjusting them, carving away at the harness to customize the fit for each individual Dora stunt performer. The shoulder armor had a vertical element that was resplendent with African etchings from top to bottom. We were successful in engineering the movement of this new addition, but only after many trial runs.

The leader of the Jabari Tribe, M'Baku, embodied by the charming Winston Duke, was outfitted with new armor as well. A gorilla face was incorporated as part of the chest piece. The big challenge was deciding what to do with M'Baku's large grass skirt, since he, too, would fight underwater. Production set up a twenty-foot

swimming pool on the John Singleton Stage. As a test, we put a stuntman in the skirt, submerged him underwater, and filmed him. That test wasn't pretty. With the buoyancy of the water, the skirt looked like some massive sea urchin. I said to myself, "Well, that won't work."

It was good for everyone to see the test. In meetings, people sometimes request a certain look for a costume, but they need a visual to see how it performs. And this visual proved that the skirt wouldn't work. In addition, M'Baku's shoes, and the reindeer pelts on his legs and back, hindered his movement in water. I began looking at Roman battle costumes. I saw a similarity in the silhouette, yet they wore sandals. This led me to realize just how I could pare down the furry, grassy costume.

The design for the Midnight Angels, played by the powerful Danai Gurira and the sensational Michaela Cole, was completely led by Ryan and Marvel's visual-development department. The illustration submissions for the Midnight Angels were focused on the images we observed in the Marvel comics. We picked one that we all liked, but when it landed on my desk, there were still elements of design that needed to be realized in order to connect it to African and Wakandan roots. It was a challenge to bring the African-inspired elements, such as the masks, to the costume. I wanted them to feel like the masks from Benin. I submitted the sketch to Russ Shinkle of Film Illusions and worked with Maybelle Penya to create surface texture and make decisions on color. The surface color we chose was a new automotive paint that changes from blue to purple as you move the piece around. I also chose a series of African patterns to run vertically down the propeller wings on the back. The armor is adorned with Wakandan writing that reads "Midnight Angels."

Nakia (Lupita Nyong'o) prepares to embark on an underwater rescue mission.

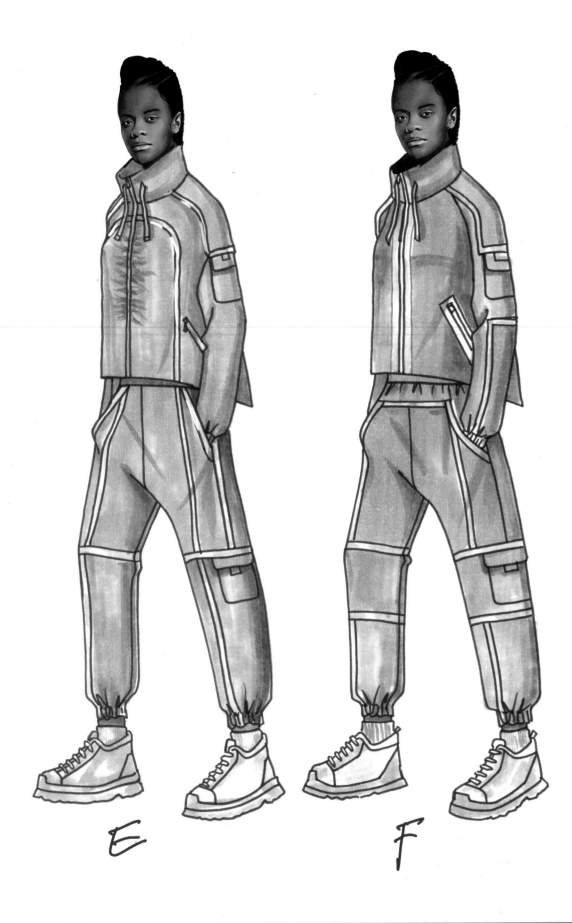

E

F

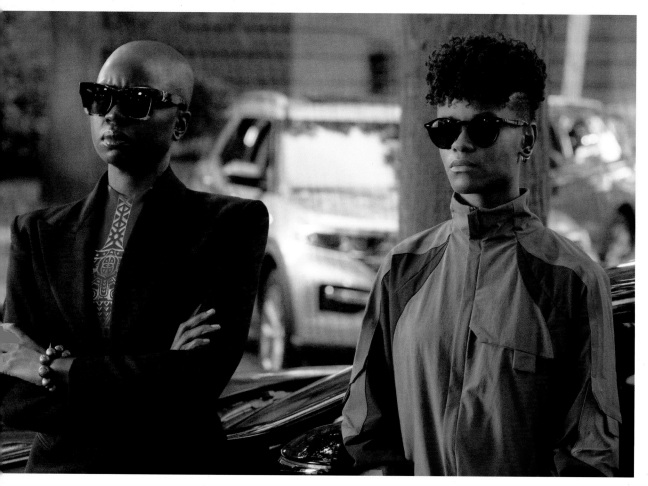

For some of the non-specialty costumes, I collaborated with the Adidas S.E.E.D. program, working with Black and Brown women who are creating the next level of sportswear. Ryan specifically requested the track suit that Shuri wears to meet Riri. We began creating a suit that would fulfill all the needs of the sequence. Purple is the color of the Wakandan royal family. It was important that the tracksuit have the aerodynamics for a wild ride on a motorcycle. We added a swing back to the suit that would fly behind Shuri as she drove. Shuri's hollow shoes, which she wears to accompany Ramonda into the bush for a traditional ritual, were also a product of our collaboration with S.E.E.D.

The most challenging costumes were built for the Talokanil. I immersed myself in studying Maya culture. Not only were the Maya colonized, but also the research about them contained many misrepresentations, and sometimes they were erased from the history books all together. It was imperative that we work closely with our historian to check our work and learn about a civilization that contributed to the culture of Mesoamerica as we know it today. Through resources like the Dresden Codex and the Maya Vase Database, we learned that the Maya wore ceremonial garments and that there were leaders and families whom you could identify through their dress and adornment.

We learned that Maya traditional costumes included sheer fabrics, prints, jewelry, adornments, wraps of all types, and headpieces. There were specific elements we used to stay authentic to the culture, one of which was the ear spool. The ear spool, or flare, was made of jade and at times mimicked a flower. Worn on the ear, it was considered a pathway to the gods, and there's hardly a Maya painting or sculpture without this detail. Using ear flares throughout the Talokanil's costumes helped achieve the right look.

We also printed our own sheer fabrics using images seen on Maya vases, painted by different artists and depicting many true-to-life scenarios of the post-classic Mesoamerican period. The

Opposite: Costume sketch for Shuri
Above: Shuri (Letitia Wright), right, with Okoye (Danai Guirira)

I needed to blend the rich culture of the Maya with the fact that the Talokanil were an underwater civilization, thousands of years old.

vases were so incredible; using imagery from them was a way to have Maya history present in the costumes, even if, once the fabric was made into a garment, the effect was more abstract. The colors and patterns created a beautiful palette.

Then I was inspired by the Jaina figurines—a set of clay sculptures excavated on a pre-Columbian archeological dig on an island off the Yucatán Peninsula. We studied the adornments on these figurines, and they presented a plethora of ideas for clothing, jewelry, and headpieces. The sculptures were a significant help in creating the look for an underwater society that lived parallel to their relatives on land.

I needed to blend the rich culture of the Maya with the fact that the Talokanil were an underwater civilization, thousands of years old. This created an additional layer of difficulty. Ancient Maya costumes were made of natural fibers, jade, shells, and clay. These elements needed to be mimicked and made of materials that could withstand being submerged in water for hours. As we had seen with M'Baku's costume, costumes underwater can be beautiful, but understanding the dynamics of buoyancy and color refraction is necessary when designing them. Fabrics float up. Weights are sometimes required to achieve a desired effect. Chlorinated water and salt water both wreak havoc on fabric dyes.

Namor, brought to life by the wonderful Tenoch Huerta, was to wear a ceremonial headpiece and shoulder piece designed to reference the feathered serpent, a Maya deity that is seen repeatedly wrapping the bodies of nobles in Maya art. The serpent symbolizes life above and below the earth

and is associated with the underworld. Namor's neck ring also contains two feathered serpents that meet at the center front, greeting a large pearl with open mouths. The pearl represents the ocean. The neck-ring design was inspired by the pyramid at Chichén Itza (also called Kukulkan), which has a staircase with two feathered serpents descending on each side; at the base the two heads face a cenote. We modeled the headpiece first in clay. The feathers were made to resemble kelp and fish fins. The serpent was cast and painted gold with elements inspired by blue and green jade and mother-of-pearl. The blue stone in the headpiece was to represent Talokan's vibranium.

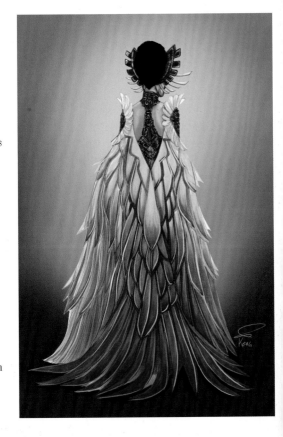

Costume sketches for Namora

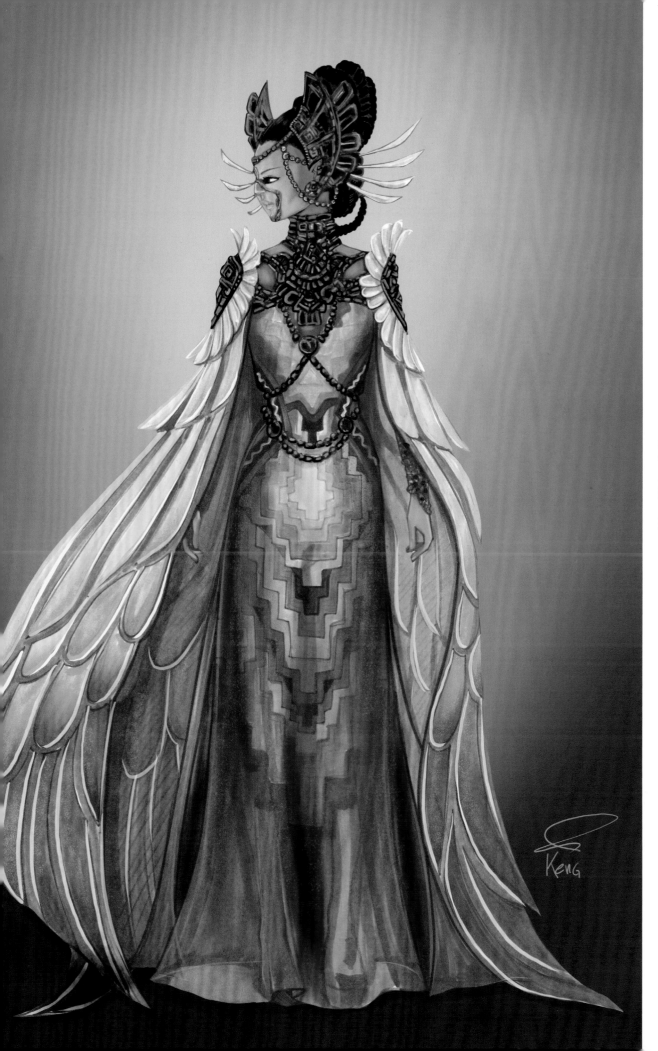

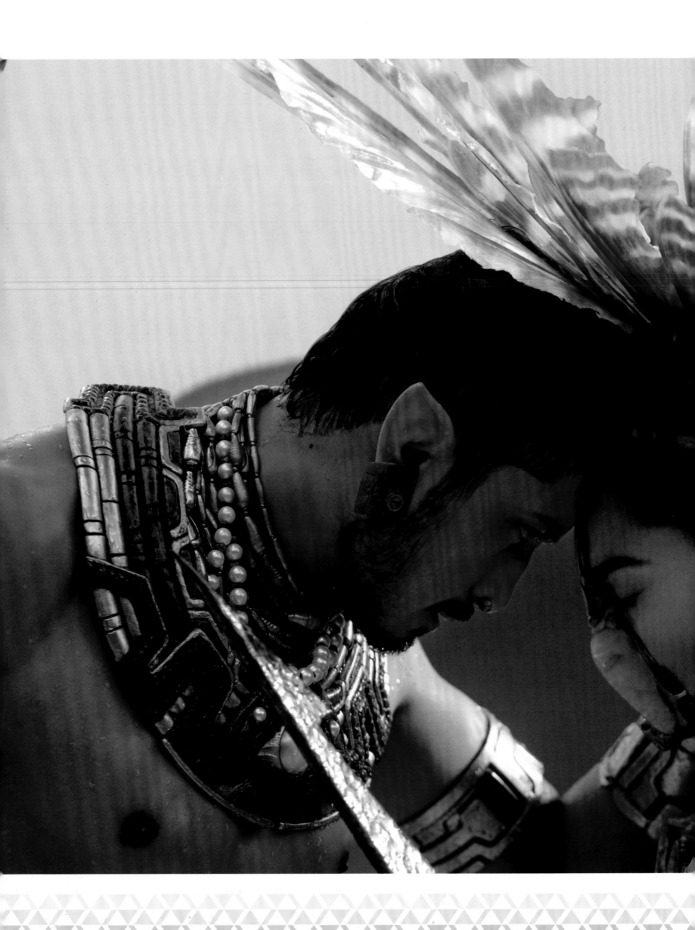

We tested the final headpiece in water, and it blew us all away.

Namora, embodied by the lovely Mabel Cadena, is Namor's cousin. She is a fierce warrior, and her costume was created to honor the lionfish. Feathers were another element we used to reference Maya culture. After discovering that feathers look strikingly like fish fins, we used them on many of the headdresses, including Namora's. We also gave her a neck piece made of fish bones. The oceanographers we consulted with informed us that fish bones are ever present on the ocean floor. Attuma, portrayed by the marvelous Alex Livinalli, also wore pieces crafted from fish bones, and his headpiece was a reference to the hammerhead shark. The number of artisans who touched these costumes, the mold work, and the beadwork, and their attention to detail and focus over thousands of hours, all contributed to creating imagery that we hope will live on in filmmaking history.

The big dynamic costume that everyone was curious about was the new Black Panther suit and who would don it. We wanted the new Black Panther design to share the same aesthetics and functions as T'Challa's suit. While the gorgeous black, silver, and gold suit was newly created for Shuri, it was imperative that we follow the aesthetic that was established in the first film as well as maintain the same connection to Africa. The Okavango triangle would cover the surface, and the molded claws and striations would be a raised design. What separated Shuri's suit from

Namor (Tenoch Huerta) and Namora (Mabel Cadena)

T'Challa's was the number of gold and silver raised pieces and the cat-faced gauntlets.

Shuri's Panther suit needed very little structure added, only enough to give the incredible Letitia Wright a dynamic superhero silhouette. I approached this with caution, wanting to present a costume that was believable. I examined Letitia's muscle sculpt and discussed with Ryan and Nate specifically what was needed. The suit's top layer includes the design details that were outlined in the sketch and explored through several fittings. The helmet was printed and tried on by the actress as well as by her stunt performers. In the end, Letitia Wright gave us chills with an incredible performance that honored her predecessor. When the Panther costume was on set, it dazzled and thrilled the crew to see T'Challa's little sister take on her new role with vitality, as she had earned the role of the Black Panther.

Looking back over my career, I have dressed superheroes of the civil rights movement and then the first Black Panther, which was a full-circle moment. I never imagined that one day I would be dressing a Black woman as a superhero in the same way. Black women have always been strong; we just have a suit now to show it.

When it's all said and done, there is a little praying that goes on. You hope that you've done it right. You wish you had more time. You want the culture to be represented in its best light, and you learn as you go.

For me, creating this new story through costumes was very different from working on the first *Black Panther* film, and equally challenging, if not more so. Especially with the crew having to wear masks or be online for most of our interactions. We had set the bar high with the first film, and we needed to meet and exceed that bar while still giving the audience something fresh and original. All of the actors connected with their costumes so deeply and were so aligned to the costume's story and meaning, that it raised up all of their performances. We get these deeply beloved characters in wearable art.

We hope that when people watch *Black Panther: Wakanda Forever* they take in an incredible movie experience, their eyes are met with vivid visual storytelling, their hearts are connected to the beloved characters' journey of grief and transformation, and their souls are enriched by finding representation and expanding their cultural horizons.

Opposite, top to bottom: Shuri (Letitia Wright) as the new Black Panther; Queen Ramonda (Angela Bassett) and Shuri performing a mourning ritual

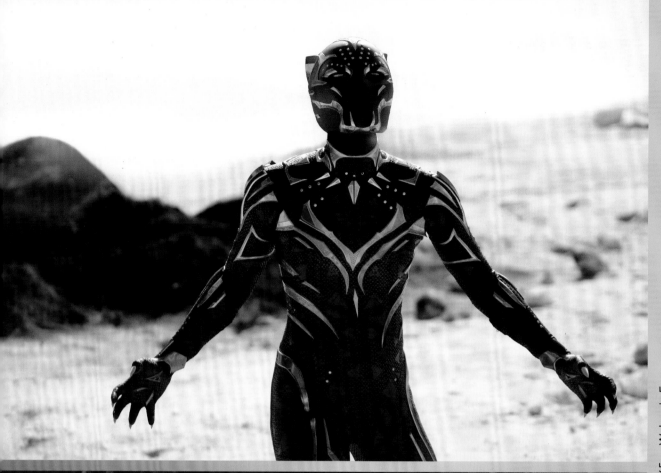

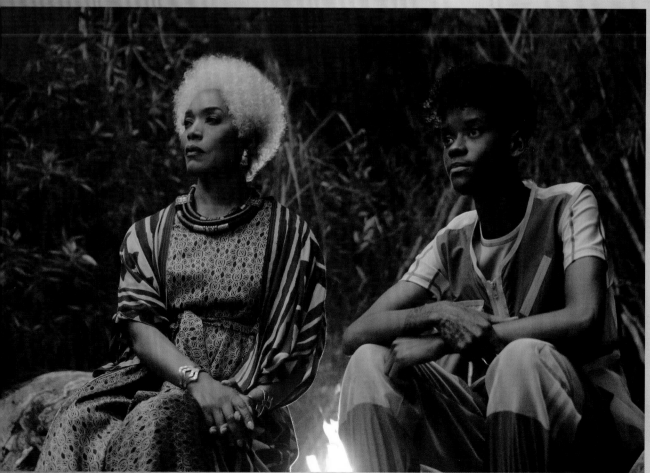

Conclusion

Throughout my career, people have always asked me: "Ruth, how did you become a costume designer? How do you come up with the ideas?" Some people think it is like magic. Well, yes, there is some of that Black Girl Magic, but I am a costume designer and a thespian at heart. I consider myself a passionate student. I am a student of people. I am a student of storytelling and history-telling. I am a student of design. I am a student of art. Studying my script, my craft, and myself.

When I began working as a costume designer, I didn't see myself as an artist. I didn't know exactly how to answer the question, "What is a costume designer?" Identifying yourself as an artist is a different process for each of us. I awaited the moment when art would arrive—not knowing it was there all the time.

First, I had to visualize and define what it means to be an artist for myself. I then dedicated myself to mastering the craft of costume design in hopes that, one day, I could be one.

This quest paired me with incredible directors and actors: Spike Lee, Denzel Washington, Angela Bassett, Chadwick Boseman, Michael B. Jordan, Oprah, Lupita Nyong'o, Danai Gurira, Ava DuVernay, Ryan Coogler, and Steven Spielberg, among others. And together, our work would leave a mark on filmmaking and storytelling.

Ruth in the costume warehouse

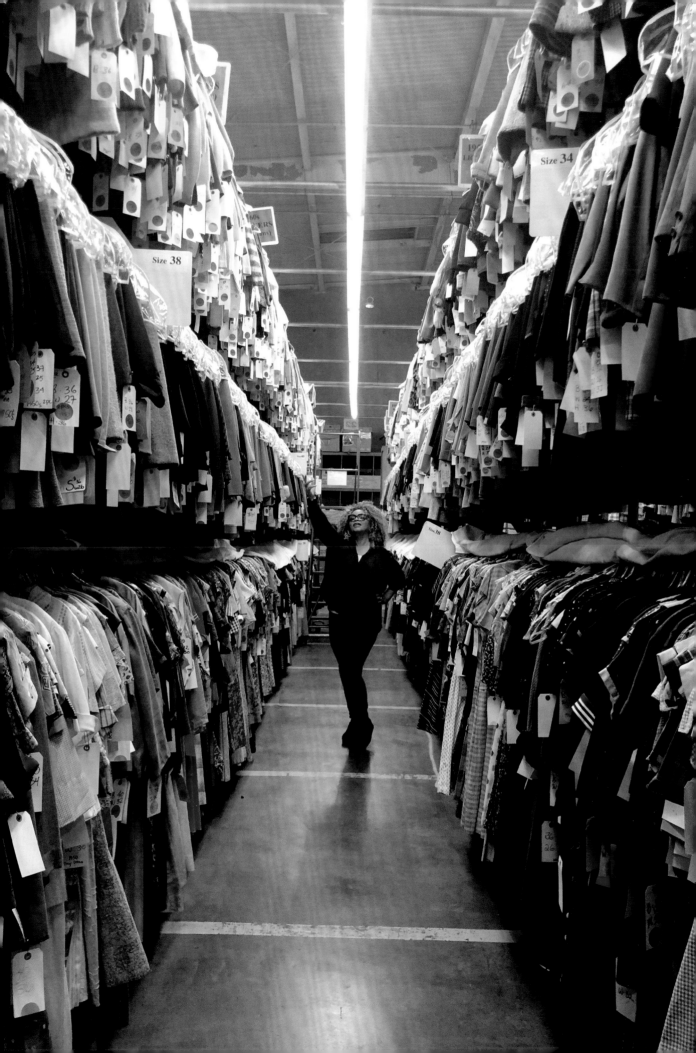

I had found my *voice*. I was showcasing a point of view, the African culture and diaspora, and intertwining technology with imagination.

Every film I work on is a special and defining experience. The brilliant young mind of director Ryan Coogler reminds me of a young Spike Lee. Ryan brought to life *Fruitvale Station*, a true-to-life protest film, much like Spike Lee did with *Do the Right Thing*. And then Ryan created a film about the Afrofuture and the first Black superhero, Black Panther. The experience of immersing myself in the beauty and depth of so many ancient African cultures—such as Lesotho, Masai, Himba, Zulu, Turkana, Tuareg, Sami, Suri, Dogon, and many others—and the opportunity to weave their cultural stories into the costumes was an incredible honor. All these traditions merged and were presented in their regal glory at the Warrior Falls.

Knowing the impact that *Black Panther* could have on the world and on the culture, then seeing our expectations pale in comparison to the reality of how the movie really did—$1.3 billion worldwide!—was incredible.

Marvel invented a comic-book superhero, and then I turned him into a real *African* king. All of this was a full-circle experience for me. It was the intersection of my own Afro past, present, and future.

Working as the costume designer on such great films as *Malcolm X*, *Amistad*, *Black Panther*, and *Coming 2 America* inspired me to reflect on my entire body of work. To see the artistry, the messages in all the costumes that I have designed through the many years, as my contribution to Afrofuturism.

I had found my *voice*. I was showcasing a point of view, the African culture and diaspora, and intertwining technology with imagination. Together with many of the actors, directors, cast, and crew, we presented possibilities. We presented Afrofuturism.

After I worked on *Black Panther*, people began to ask me how it felt to design superheroes. The truth is, over my whole career, I have been designing costumes for superheroes: Malcolm X, Dr. King, Betty Shabazz, Coretta Scott King, Cinqué, the White House butler, Thurgood Marshall, and Amelia Boynton. These same heroes and, let me add, "sheroes" who helped shape our country also helped me build my voice in Afrofuturism. Each historical and imagined figure I was able to design clothing for, some of whom we will never forget, wore coats of armor cloaked in human rights. And others wear Black super suits and are embedded in the psyche of American culture by enriching the narrative of the Black experience.

I'm constantly inspired and carry with me a message that each figure shares from film to film. I continue to build myself and my career and find my voice as an artist in Afrofuturism. We are living in a time when it feels like we need a superhero. The ideals of democracy are being tested. But from these many films in which I've dressed superheroes, the lesson to take away is that during troubling times, *art* is often what truly allows a nation to reflect on the human experience and shows us our collective consciousness.

Art is usually seen as an expression of truth, making the courage to share it that much more impactful. It prompts a heavy dialogue that can open up avenues necessary for change, healing, and hope. To all of the young costume designers: In your pursuit of truth, be fearless about becoming artists. You are just beginning your journeys as storytellers in the performing, cinematic, and media arts at a time when the curtain has been lifted. When voices once silenced are now being heard shouting "me too" and "time's up." When equal pay benefits all. When inclusion and representation are not only making a difference at the box office, but also enriching our collective storybook and allowing young people to see something greater in themselves.

T'Challa is empowered by the powers of the heart-shaped violet herb. We are all empowered by our own private self-will. I didn't always know the reasons why going forward, but I surely understand now looking back.

Don't be afraid to make great sacrifices to better your life and the lives of your loved ones. I did. No matter what challenges I faced, hardships I endured, personal tragedies I went through, heartaches and heartbreaks, when I came back to my work—the artistry, the creativity, and the design—when I came back to my purpose, everything felt right.

Simply trust the journey.

And you will find in yourself the artist.

Acknowledgments

I've had the pleasure of working with some of the most prolific filmmakers in Hollywood. Thank you to the all the directors who allowed me to realize their vision. And thank you for giving me the gift of fulfilling my own personal calling. I am grateful to them for believing in me and for beginning my lifetime connection in film.

Thank you, Danai Gurira, for writing the eloquent foreword. Together, we were able to ignite the magnificence of the African diaspora and the majesty of new beauty standards for all the world to see. To all the actors who stood so beautifully in front of the mirror and shared the power of *their* presence: You are my canvas and my muse.

Thank you to Meera Manek for the right words. And to Larry Steele for the right kind of love. You keep my head and my heart together.

It is my hope that my book serves as a model for young designers who want to discover their passion, find their artistic vision, and embrace it as we strive to change the world through the power of costume design and our vision for tomorrow.

I dedicate this book to my mother, Mabel Virginia Carter. Her deep compassion for others opened my world, allowing me to see the layers behind the faces, and helped me have the vision to become a better designer. She exemplifies an unwavering personal strength and dignity through her own struggle as a single mother of eight. Thank you, Mom, for believing in me and my journey.

She's now 102 years old.

Image Credits